RENÉ

MAGRITTE

A. M. HAMMACHER

THAMES AND HUDSON

ACKNOWLEDGMENTS

à ma femme
Renilde

The preparatory work for a book on Magritte involves research of various kinds and contacts with people who knew the artist well. Many of these people went to great trouble to answer the questions I put to them, often showing so much devotion to a period now past that a few words of thanks are appropriate here.

Time after time Madame Georgette Magritte proved ready to supply information and to search out documentary material. Of the small circle of Surrealists who surrounded Magritte years ago, it was Irène Hamoir and Louis Scutenaire (with their splendid collection) who did much to make those years come to life again. Madame Francine Legrand, Keeper of the Musées Royaux des Beaux-Arts de Belgique in Brussels, and the attachés lightened my task when it came to studying the already considerable amount of documentary material on Magritte and his circle now in the Archives de l'Art Contemporain. Madame Margaret Krebs provided information and documentation regarding the whereabouts of some of Magritte's works and recollections of her contacts with René and Georgette.

Francis de Lulle, head of the Art Information Department of the Ministry of Culture in Brussels, and Catherine de Croës, attachée, were particularly hospitable. In New York, Harry Torczyner, a friend of Magritte's in his later years, proved an indispensable and generous guide to "Magritte and America." Pierre Crowet, Emile Langui, Jacques and Roger Nellens (after the death of their father, Gustave), Edward James, Messrs. L. Bickerton and M. Heymann of the Edward James Foundation, and Mr. D. Rogers of the museum at Brighton lent the author both documentary and moral support. I am grateful to all of them.

A. M. HAMMACHER

Translated by James Brockway

First published in Great Britain in 1986
by Thames and Hudson Ltd, London

This is a concise edition of A. M. Hammacher's *Magritte,*
originally published in 1974

Picture reproduction rights reserved by A.D.A.G.P., Paris

Printed and bound in Japan

CONTENTS

magritte

René Magritte was no doubt disappointed that, aside from the small circle of his kindred spirits among the Surrealists, the world needed over a quarter of a century to discover that his work has both philosophical and poetic content which corresponds to certain social and intellectual trends, particularly of the second half of the twentieth century. Magritte's work was not easy to approach at the outset, however. He is a difficult painter, and his simplicity is misleading. A world ever more disturbed and unstable—in labor, trade, and industry, as well as in intellectual and university circles—is a world in which reason remains indispensable. Yet the irrational no longer allows itself to be thrust aside, and today it is struggling to win recognition. As a result, there is now a greater possibility, especially among the younger generation, to arrive at a better and deeper understanding of Magritte's art.

His work makes a constant call on us to relinquish, at least temporarily, our usual expectations of art. Magritte never responds to our demands and expectations. He offers us something else instead. His friend Paul Nougé has expressed the problem better than anyone else; what he said in 1944 still holds good: "We question pictures," he said, "before listening to them, we question them at random. And we are astonished when the reply we had expected is not forthcoming."[1]

Magritte's work allows one to conjure up a state of being which has become rare and precious—which makes it possible to observe in silence. Reading and reflection call for silence, listening no less. Silence can be used for waiting for an illumined vision of things, and it is to this vision that Magritte introduces us.

With Magritte's work preceding 1925 the practiced art historian is able to trace, describe, analyze, and define the relationship between the artist's abstract-Futurist-Cubist experiments and the existing avant-garde movements, especially in Belgium and Paris. After this date, however, when Magritte became involved in Surrealism, a radical change occurred in his art which makes the art historian's discipline of biography, description, and dating largely ineffective in understanding the significance and the essence of Magritte's painting.

Historically, Surrealism—the most complex phenomenon in twentieth-century art to date, embracing literature, painting, sculpture, the theater, and the cinema—can be seen within a certain cultural, sociological, and political framework. Since Magritte is associated with Surrealism—his work represents a constituent element—placing that work in the mental environment in which it evolved is an absorbing task. Whoever wishes to understand more about the fascinating mystery and challenge in Magritte's

oeuvre will not, however, get very far with biographical, analytical, or sociohistorical inquiries.

Magritte's private life permits little psychoanalytical excavation. To undertake such work would be to disregard the ban the artist himself laid on such investigation, yet this need not mean that any prospective lawbreaker would not come home with valuable booty. Magritte's unwillingness to talk about the past and his feigned indifference to highly disturbing events in his youth are obviously due to repression. His past must have been a source of powerful uncon-

1. LADY IN A BLUE CLOAK. 1922. Oil on canvas, 28 x 16¼". *Acoris, the Surrealist Art Centre, London*

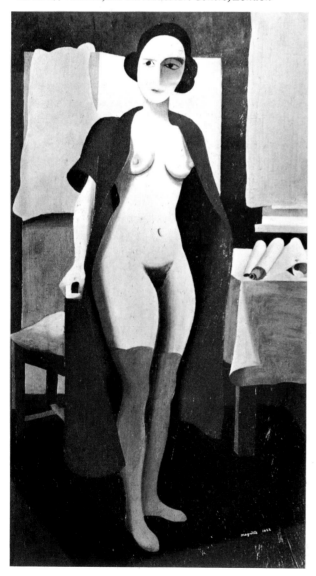

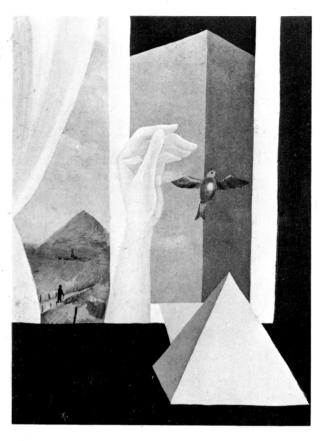

2. THE WINDOW. *La Fenêtre.* 1925. Oil on canvas, 25¾ x 19½". *Private collection, Brussels*

scious influences, yet he was right in thinking that searching for an explanation which attributed his work to traumas or other events in his childhood, or which sought to unravel his dream symbolism, would be precisely the opposite of what he was consciously aiming for in his painting. Seeking solutions by going to cabalism—as in the latest efforts to interpret his work—is wholly at variance with Magritte's mental makeup and leads to results which flagrantly contradict the information we have available.

Through self-inquiry and experimentation, Magritte dissociated his work from the problems explored by the Cubist avant-garde and their circle, who had held sway during his younger years. He preferred the rebel atmosphere of Surrealism, which had absorbed its Dadaist background and reactions to the war psychosis generated by World War I. In Surrealism, too, he was no conformist. Strongly opposed to self-projection and self-expression, he rightly objected to his work being reduced to personal, psycho-

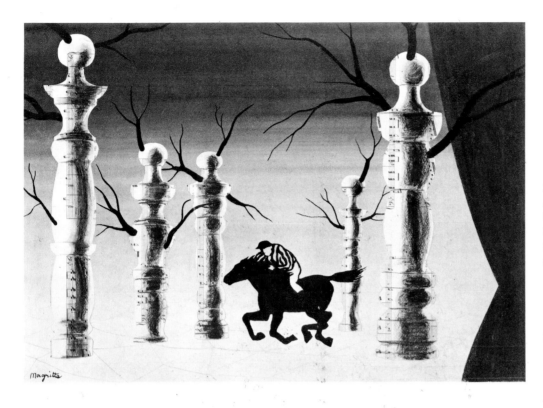

3. THE LOST JOCKEY. *Le Jockey perdu.* 1926. Collage and watercolor on paper, 15¾ x 22". *Collection Max Janlet, Brussels*

4. LANDSCAPE. *Paysage.* 1926. Oil on canvas, 39½ x 28⅜". *Private collection, Brussels*

5. THE RECKLESS SLEEPER. *Le Dormeur téméraire.* 1927. Oil on canvas, 43¼ x 33½". *Tate Gallery, London*

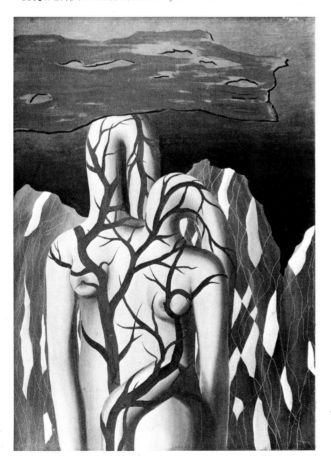

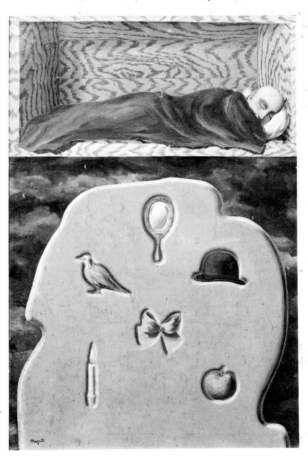

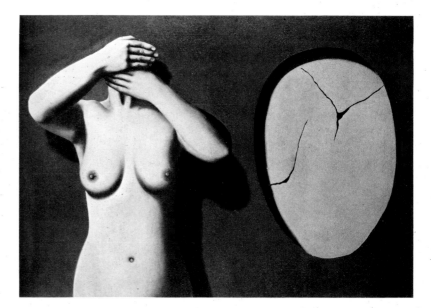

6. NOCTURNE. *Le Genre nocturne.*
1928. Oil on canvas, 31½ x 45".
Private collection, Belgium

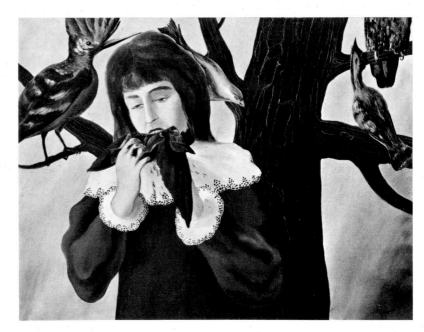

7. "PLEASURE." *"Le Plaisir."* 1926.
Oil on canvas, 29½ x 39⅜".
Collection Marlborough Fine Arts, Ltd.,
London

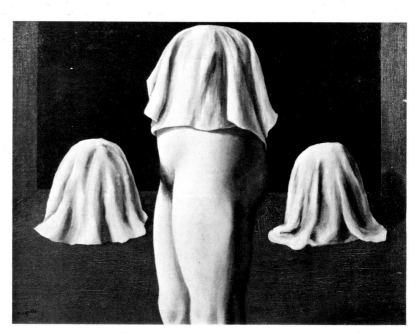

8. THE SYMMETRICAL TRICK.
La Ruse symétrique. 1927.
Oil on canvas, 21¼ x 28¾".
Collection M. and Mme Marcel Mabille,
Rhode-St-Genèse, Belgium

logical, and aesthetic considerations—and thereby rendered harmless to society. He was not in agreement with the society in which he lived and, though he was of too skeptical, critical, and ironical a turn of mind to think that his art could reform it, he did see a visual instrument in his art by which people might, via shock and surprise, become aware of the lie behind conventions and be able to find the way back to the mysterious essence of things.

The fascinating and challenging images in Magritte's works stem from revelations of the mystery of the visible world. To him this world was a more than adequate source of lucid revelations, so that he did not need to draw on dreams, hallucinations, occult phenomena, cabalism. Nonetheless, preconsciousness —that is, the state before and during waking up—always played an important role in his work.

In studying Magritte one begins to understand that attempting to solve puzzles must be avoided, but the artist himself provides clues to his manner of painting and the mental process on which it is founded. Some are inclined to call this process "visual thinking." I prefer to give it no name. The term "visual thinking" is not subtle enough and involves too many misunder-

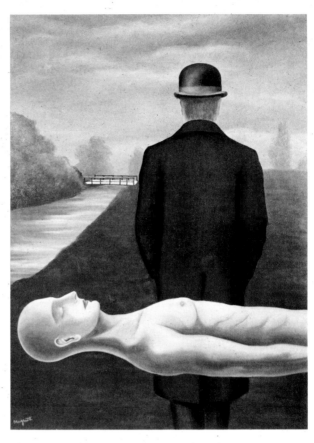

9. THE MUSINGS OF THE SOLITARY WALKER.
Les Rêveries du promeneur solitaire. 1926–27.
Oil on canvas, 54¾ x 41⅜".
Private collection, Brussels

10. THE FIXED IDEA.
L'Idée fixe. 1927.
Oil on canvas,
31¼ x 45¼".
*Collection
Alexandre Iolas,
Paris*

11

standings regarding the possible subordination of the visual to thought, or vice versa. The misunderstanding caused by calling Magritte "cerebral" has also been demonstrated all too often, despite the unusually large quantity of literary, philosophical, and linguistic affinities Magritte's work suggests, and which bring us closer to their meaning. Also the term "literary" is a misconception in his case, although it is understandable because of the literary origins of the leading figures in Surrealism. Let us refrain, then, from favoring one formula or the other and instead take a frank look to see with whom, and with what, Magritte and his marvelous cabinet of instruments can be compared.

The author who wishes to show complete respect for the struggle Magritte waged against faulty interpretations and explanations—and it was indeed a struggle—nevertheless finds he has to ignore Magritte's own personal ban. Even Magritte himself attempted to explain why he wanted *no* explanations.

His pronounced hostility to the idea of the symbol in relation to his work, his undisguised dislike of psychoanalysis in particular, and his distrust of any and every interpretation naturally had reasons. He was defending the very essence of his work by adopting this attitude. If, therefore, we try to understand something of the *meaning* of his resistance—and Magritte never forbade us to attempt that—we shall come closer to his work by this roundabout way.

Seeing, says Magritte, is what matters. Seeing must suffice. But what kind of seeing must it be? Of what quality? A form of understanding is possible beyond the confines of any verbal explanation, which, if it is of any use at all, must be authenticated by a way of seeing. Unfortunately, for a large proportion of the public, seeing is not sufficient. People often see things hastily and think about them carelessly; they have been educated in disciplines and traditions in which words represent ideas and have a dominant function. This function has left the realm of revelation *beyond words* neglected and unexplored.

Magritte, who was a painter and a painter *tout court*, albeit an unusual one, was nevertheless more aware than any of his contemporaries of words and of the dubious status they had acquired. His conscious-

11. Giorgio de Chirico. THE JEWISH ANGEL. 1916.
Oil on canvas, 26½ x 17¼".
Collection Sir Roland Penrose, London

ness of words is evident in both his writings and paintings. Dealing with words was a dangerous game to play, though, for by playing it he introduced the element "word" into his painted "images." Thus, anyone seriously concerned with Magritte's work cannot avoid taking a thorough account of what Magritte sought of words in his work and of the value he attached to them.

The simplicity in his work is a suspect simplicity. In his writings—which include general articles, a few literary pieces, and special articles on specific themes —and in the titles he gave to his works, Magritte was methodical, as he was in his painting. The unexpected is never mere caprice. Moreover, it resides not so much in Magritte as in ourselves. We are not prepared for, and we do not instantly grasp, his technique of thinking and painting. It is not recalcitrance on his part but a natural need to react to the stereotype phe-

12. Giorgio de Chirico. SPAN OF BLACK LADDERS.
1914. Oil on canvas, 23¾ x 19½". *Collection
Mr. and Mrs. James W. Alsdorf, Winnetka, Illinois*

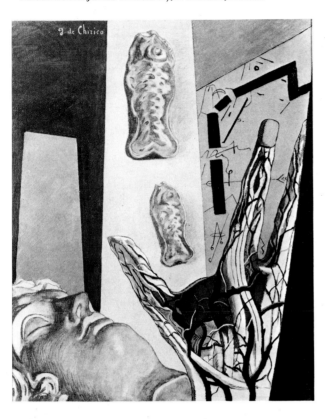

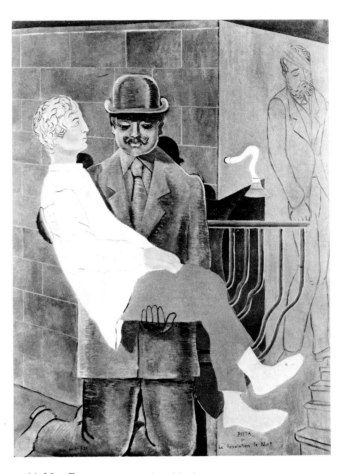

14. Max Ernst. PIETA OR REVOLUTION BY NIGHT.
1923. Oil on canvas, 45⅝ x 35".
Formerly Collection Sir Roland Penrose, London

13. Giorgio de Chirico. THE CHILD'S BRAIN.
1914. Oil on canvas, 32 x 25½".
Moderna Museet, Nationalmuseum, Stockholm

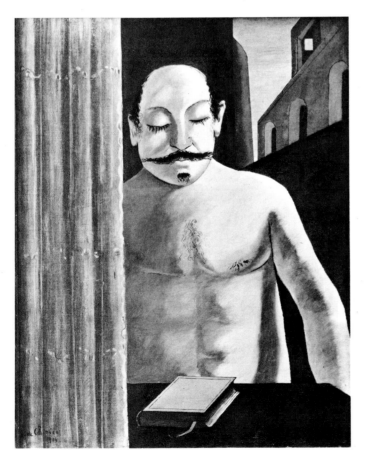

15. Giorgio de Chirico. THE DOUBLE DREAM OF SPRING.
1915. Oil on canvas, 22⅛ x 21⅜". *The Museum of Modern Art,
New York City. Gift of James Thrall Soby*

nomena of everyday life in a way contrary to expectation; it is a need to correct. What is more, in Magritte's work this became a discipline of feeling, thinking, and behaving which he discovered and evolved for himself. Accordingly, his method—others feel it was a discipline—is as valid a subject for our inquiry as the works themselves.

Magritte attempted, as it were, to achieve a controlled resonance in his work. After he had finished a painting, it set up a resonance within him, in which he involved his closest friends. This resonance in the artist himself was necessarily different from that in us, who are the uninitiated in regard to his pictorial and verbal imagery. Yet, despite everything, Magritte probably attached more than usual importance to having people feel the right kind of resonance. That he could do anything about this himself was an illusion; the others were the critics, the art historians, the museums, the art dealers, the collectors, who play their own game with a variety of intentions.

More often than not, Magritte chose ordinary things from which to construct his works—trees, chairs, tables, doors, windows, shoes, shelves, landscapes, people. He wanted to be understood via these ordinary things. Those who find him obscure should not forget that he had turned his back on the fantastic and on the immediate world of dreams. He did not seek to be obscure. On the contrary, he sought through a therapy of shock and surprise to liberate our conventional vision from its obscurity.

In this book let us therefore keep, so far as we can, to Magritte himself, to his own resonance, to his method. Even though his is a complex, sophisticated world in which we often lose sight of simplicity, we are able to find this simplicity again in the works themselves, a fact that can only increase our astonishment.

Magritte's Lucid Dreams

Generally speaking, Magritte rejected the dream as a source for his paintings: "The word 'dream' is often misused concerning my painting. We certainly wish the realm of dreams to be respectable—but our works are not oneiric. *On the contrary*. If 'dreams' are concerned in this context, they are very different from those we have while sleeping. It is a question rather of *self-willed* 'dreams,' in which nothing is as vague as those feelings one has when escaping in dreams.... 'Dreams' which are not intended to make you sleep but to wake you up."[2]

So the situation is not so simple as Magritte's outright rejection of the dream would make it seem. He evidently had in mind the experiences we have just before waking up, but he made no distinction between waking dreams, lucid dreams, and half-dreams. Yet, this still does not explain the mechanism through which his unusual images resulted. Magritte was apparently unfamiliar with the category of "lucid dreams," which differ from normal dream experiences as described in the psychoanalytical interpretations of Freud and his followers. The information we have on this subject suggests that not only did he have lucid dreams but he gave them some thought as well.

Max Ernst, who in 1961 had seen a Magritte exhibition in London in the Obelisk Gallery, wrote intuitively: "Magritte neither sleeps nor remains awake. He illumines. He violates methodically, without laughing."[3]

From one of Magritte's own lectures, Louis Scutenaire quotes the phrase "the representation of certain visions of half-sleep,"[4] which Magritte mentioned as one of the means of rendering objects startling and of establishing a deep contact between the consciousness and the outside world. In the same lecture Magritte relates that, in 1936, he once woke up in a room where there was a birdcage with a bird dozing in it. He terms it "a magnificent error" that instead of seeing a bird in the cage he saw an egg in its place.[5] The shock this transformation gave him was created by the affinity between two unrelated objects—the cage and the egg. Camille Goemans rightly refers to it as a rare "poetic shock" stimulated by the "mental system" and the "sensory system."[6] Magritte does not say that he had awakened out of a dream, but he does say that waking caused him to see *what was not there*.

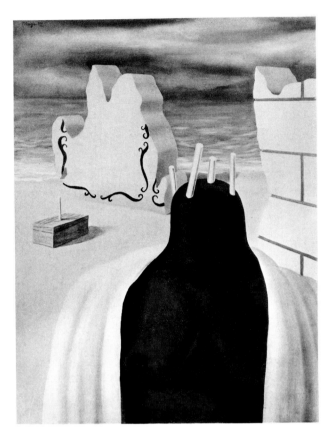

16. THE VESTAL'S AGONY. *Le Supplice de la Vestale.*
1926. Oil on canvas, 38⅛ x 29⅛".
Collection Isy Brachot, Brussels and Knokke-Le Zoute

When I open my eyes, thoughts crowd in on me. They are the things I saw the day before. I also recall things I dreamed about during the night. I always remember them with a sense of great happiness and it is like a victory for me when I succeed in reconquering the world of my dreams. It had already occurred to me how strange my morning thoughts were; it seemed it was a matter of remembering the greatest possible number of things and however much I recall I never go back more than twenty-four hours into the past. I take account of it as soon as it occurs to me to check.

There is a blending of originally repressed memories of people seen the previous evening and unseen

He might have seen some dream image before waking up.

This involuntary experience led Magritte to work out a technique of investigation to discover an element peculiar to every object which in some recondite way linked it to some other object. This made him feel that, thanks to these discoveries, he possessed a kind of prescience that had been lost. That which he sought to bring to light was hidden away in the unconscious or had been repressed. It was only after a whole series of inquiries that he found what he was looking for.

Magritte's statements from the 1927–28 period, during his Paris years (published by Marcel Mariën in *Les Jambes du ciel*, no. 6 of the Editions Les Lèvres Nues, 1968), are also significant. Here, too, he speaks of a waking situation and seeks to find out whether he had dreamed of the things he saw during the night or had actually seen them when awake the previous day or evening:

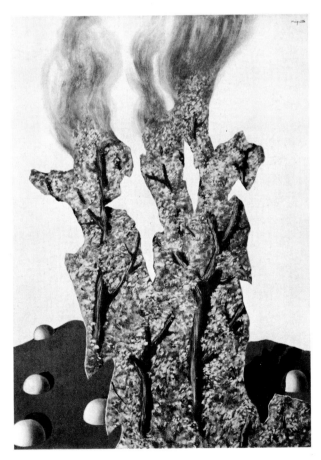

17. COUNTRYSIDE III. *Campagne III.* 1927.
Oil on canvas, 28⅞ x 21¼".
Collection Isy Brachot, Brussels and Knokke-Le Zoute

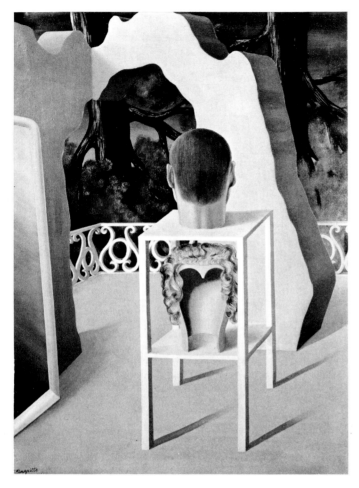

18. THE MIDNIGHT MARRIAGE. *Le Mariage de minuit.*
1926. Oil on canvas, 55 x 43".
Musées Royaux des Beaux-Arts de Belgique, Brussels

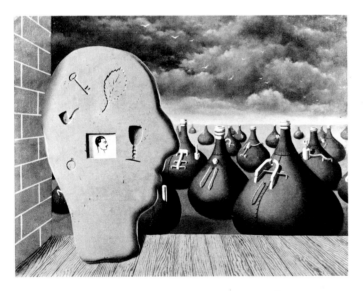

19. THE SPONTANEOUS GENERATION. *La Génération spontanée.* 1937. Oil on canvas, 21½ x 28⅞".
Private collection, Antwerp

but dreamed-of landscapes. For example, Magritte locates what he experienced on one of the South Seas islands and writes of moving through violet water (reminiscent of Gaugin's paintings) on "red wires at the mercy of invisible and doubtless violent currents. In advancing, a woman made of plaster causes me to make a movement designed to lead me a long way."

He distinguishes between hallucination and recollections of recent actual experiences as follows: "In recalling these things, I discovered all at once that they did not belong to a dream. That woman on a bicycle—her I had seen the previous evening as I came out of a cinema."

The mood of this rather oppressive prose, fraught with anxiety, corresponds exactly with that of the paintings of the years 1926–28, beginning with the strange landscapes of 1926. After 1930 these semi-dream faces, with a touch of the oppressiveness of hallucinations about them, did not occur again in the same manner. Magritte continued, however, to stress the poetic image becoming conscious and visible, rather than symbolic values or the significance of dreams, to the end of his life.

In an exchange of disputatious letters with the Belgian Surrealist Achille Chavée, concerning the latter's interpretations of a few paintings, Magritte again touches on the subject of the "dream," in the same way as he spoke in 1927–28 of lucid dreams on waking. In his polemic with Chavée he inverts the Freudian mechanism in a marginal note: "As regards the Freudian interpretation of objects, it is very important, I think, to notice—and this is one of the conditions of poetry—that, if, for example, in a dream a tie indicates a sex, *if the dream is a translation of waking life, waking life is also a translation of the dream.*" And in a letter dated May 9, 1967[7]—and belonging, therefore, to the last days of his life—I came across the phrase "an unpredictable image appeared to me last night," followed by a sketch of a plant with three different types of flower and a brief description.

We do not know whether the image occurred in a state of semisleep or in a deep dream. However, we are able to conclude that—although according to his wife, Georgette, Magritte seldom spoke of dreams

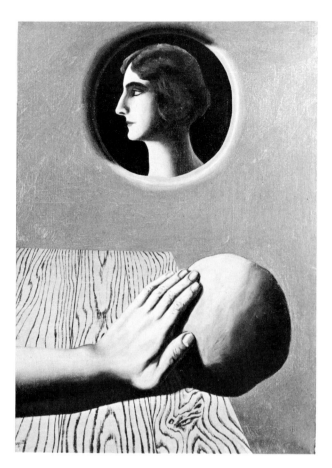

20. THE SALUTARY PROMISE. *La Promesse salutaire.*
1927. Oil on canvas, 28¾ x 21¼″. *Private collection*

(Walker Art Center, Minneapolis, page 62). It shows his clear opposition to "fantastic art and symbolic art," which he disavows and sees as a likely prey for the psychoanalysts.

In a letter written from London on March 12, 1937,[9] and addressed to his friend the poet Paul Colinet, Magritte offers an ironical report. (This letter is typed in English, because at the time Magritte had an English typist, and it shows the address 35, Wimpole Street, London W., which was the home of Edward James, where the artist was lodging at the time.) A young painter, Matta, had taken him to two psychoanalysts. One was a young South African, who had begun working as a surgeon. "Because he is interested in the works of our friend Freud," Magritte writes, "this young doctor is evidently very much interested—that goes without saying—by [*sic*] surrealism." The second psychoanalyst was about fifty,

21. THE AMOROUS PERSPECTIVE. *La Perspective amoureuse.* 1935. Oil on canvas, 45¼ x 31½″. *Private collection, Brussels*

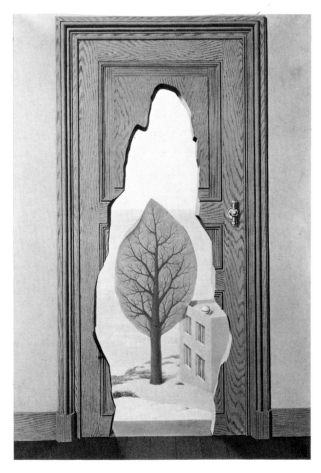

and seemed to pay little attention to them—Magritte did, in regard to his dreams, endeavor to arrive at a clear idea of what belonged to the world of dreams and what to the survival in the memory of things recently seen or experienced. Moreover, he stated that the moment of waking was significant.

Louis Scutenaire mentions an instance of a nightmare Magritte had in the home of Edward James in 1937. He felt himself threatened by ghosts tugging at his legs and, according to Georgette, he shrieked out in an alarming fashion. That night they did not dare go to bed again.[8]

In regard to psychoanalysis, Magritte is ironical; he fends it off. He never overcame his aversion to it, which indeed grew stronger with the years. There is proof of this in his statement of May 21, 1962, for the catalogue of the *Vision of René Magritte* exhibition

and Magritte spent an evening with the two men. After they had asked him all about the subject matter of his paintings, they felt able to interpret it. "Thus, they think my picture 'The Red Model' is an example of castration. You will see from this how simple it all becomes. Also, after several interpretations of this kind, I made a real psycho-analytical drawing (you know what I mean): Canon bibital etc. ...Of course, they analysed these pictures with the same coldness. Just between ourselves, it is terrifying to see what one is exposed to in making an innocent sketch."

Not so much the rejection itself but the emotional and stubborn manner in which he expressed it may be connected in some way with the fact that in Belgium the poet, essayist, and novelist Franz Hellens popularized the idea of Freud and Jung in relation to literature and even represented *"le fantastique réel,"* which was why Paul Delvaux became his illustrator. Magritte did not at all wish to participate in these circles.

He stated his position about his art in the following argument (taken from the letter of March 12, 1937, to Paul Colinet), which, however, is an untenable one: "Art, as I see it, is refractory to psychoanalysis: it evokes the mystery without which the world would not exist, that is to say, the mystery one must not confuse with a sort of problem, difficult though it may be." To this he adds that he has to be wide awake to evoke the mystery of the world and must not identify himself with ideas, sentiments, or sensations that occur in dreams or in a state of insanity.

The mystery of the world is beyond the psychoanalysts, Magritte believed: "No one of good sense believes that psycho-analysis could elucidate the mystery of the world. To put it precisely, the nature of the mystery annihilates curiosity." Since what Magritte's work does exactly is to evoke the mystery, his conclusion is, "Psycho-analysis has nothing to tell us either about works of art, which evoke the mystery of the world." He adds, maliciously: "Perhaps psycho-analysis itself is a better subject for psycho-analysis." He could hardly be more hostile.

To lay a ban on any interpretation of oneself is to place oneself in an untenable position. Yet Magritte's attitude can be explained. He was defending himself and in doing so he distorted the psychoanalysts' intentions. His anxiety that he might be misunderstood also made him overlook the fact that psychoanalytical inquiry can approximate the process of creativity. A good psychiatrist, moreover, is aware of his method's limitations and of the things which have so far remained inaccessible to the tools he has at his command. But Magritte wanted to prevent any viewer of his work from identifying himself with the artist in the same way as he prevented himself, as an artist, from identifying with sentiments, sensations, ideas. He strove to attain an objectivity which would make it only logical that he should reject such art as Vincent van Gogh's. He provided people with a means which would not lead them back to Magritte, not back to his unconscious, but forward to that strange and mysterious world which every day, on waking up, reveals itself to the eye of consciousness.

An important element emerges from all his contestable attitudes: he regarded the mystery of life with a sacred awe and considered the essence to be impervious to all interpretation. Thus his attitude does not apply to psychoanalysis alone; it applies equally to interpretations by art historians, art critics, and philosophers. The paradox is that in his play with titles and also in brief texts by himself or his friends, Magritte did not escape from the impulse to do something *with words* in addition to, or even *in* his painting—something that might be termed a disguised form of commentary. But commentary is not quite the same thing as an interpretation.

Achille Chavée, who rightly opposes Magritte's condemnation of all interpretation, applies Magritte's general conclusion regarding *"la vie éveillée"* to the work of art: "A truly poetic canvas is an awakened dream."[10] Magritte cannot but have agreed with this formula, for here Chavée is talking of the waking dream, to which the lucid dream is closer than it is to the ordinary dream. Everything in Magritte tends toward lucid, conscious, visible phenomena, and he was strongly opposed to what Chavée does—and not Chavée alone but countless others too—when he seeks the latent behind the manifest content.

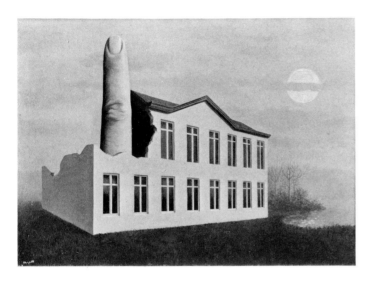

22. THE REVELATION OF THE PRESENT. *La Révélation du présent*. 1936. Oil on canvas, 18⅛ x 25⅝".

As I have already suggested, all these data point in the direction of the *lucid-dream technique* and associated phenomena. Semidream states, as noted and analyzed by the Russian philosopher Ouspensky—though not in the manner of Freud, whom he rejected—must have occurred repeatedly in Magritte's life. (On this we may consult the work *Lucid Dreams* by Celia Green, director of the Institute of Psychophysical Research in Oxford, which includes frequent quotations from Ouspensky and also from Van Eeden, the Dutch doctor and author.) Like Magritte, Ouspensky found that he was better able to observe his semidream states in the morning when he was still lying in bed awake than in the evening before falling asleep.[11] Ouspensky also speaks of the sensation of triumph, or at least of immense satisfaction,

23. THE EMPIRE OF LIGHTS VII. *L'Empire des lumières VII*. 1961. Oil on canvas, 44⅞ x 57½". *Private collection, Brussels*

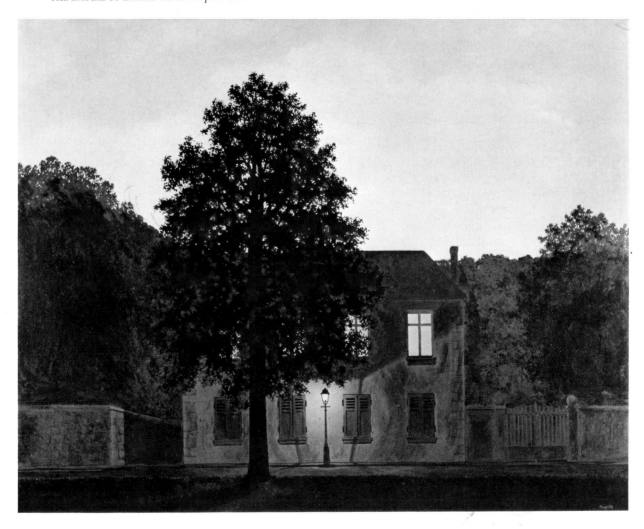

19

that he had whenever he succeeded in pinning down the origin and nature of his experiences. Thus Magritte had a lot in common with lucid-dreamers, whose experiences have been recorded and studied on a scientific basis.

The fact that the lucid dream leaves behind it an impression of being related to the daytime world rather than to the nighttime or dream world explains why Magritte had so strong an urge to seek the side of consciousness, including consciousness of the irrational and unknown, and to turn away from everything that tended toward unconsciousness, somnambulism, hypnosis, automatism, and obscurantism. This also lay behind his resistance during his Paris period to an influential man like André Breton and his circle, where the artificial return to living in the subconscious and the unconscious was practiced with passion.

Magritte did not like letting himself go; his self-control was highly developed. Even in the realm of the half-conscious, his urge was toward control, consciousness, exactitude. Like Ouspensky, he was familiar with those delicate, brittle states of lucidity during sleep in which the sleeper is conscious of himself. Knowing Lautréamont's (Isidore Ducasse's) *Les Chants de Maldoror* well—he illustrated the work twice, in 1938 and 1948—he must have recognized himself in strophe 3 and song V: "Nevertheless I sometimes dream, though without for a single moment losing a lively awareness of my personality and my freedom of movement."

Like more practiced lucid-dreamers than himself, Magritte possessed the technique of conjuring up his "image" *at will* and of controlling it. The image was related to reality, except during his pre-1933 period. This can be referred to as the "self-willed dream," an expression which has evolved from correspondence and conversations with those persons who knew Magritte well, without any attempt made to use scientific terminology. The first time a concealed connection between objects or between images which had risen out of the semidream revealed itself, the tension must have been greater than later on, when Magritte repeated his paintings—which he often did. The attempt to determine actual dates—a matter

in which he was not careful or helpful, or did not wish to be—is not therefore without importance. Nevertheless, Magritte's capacity to conjure up "images" *at will* may have lent any repetition a new and greater importance. Where his reprises have failed to benefit by this gift, they have often turned out to be below his usual standard.

The Problem of Magritte's Titles

The significance of the titles Magritte gave to his works seems to be of secondary importance to the works themselves. Yet if we inquire into the origins, history, and intention of these obscure and hermetically sealed titles, we are taken immediately to the very heart of his Surrealist painting.

We can be sure of the following few facts. The titles always came into being *after* the work was created. This is often the case in art, but in Surrealism it is true generally, and in Magritte's Surrealism particularly it means that the genesis of a theme must be dissociated from experiences, objects, events, transactions, and situations described in words. If a theme arises independently of words, we are at once confronted with the contradiction that Surrealism in art —and Magritte's brand especially—nevertheless had unmistakable links with literature; this has led hasty critics to look for its merits in its literary content, while paying less attention to other sources.

According to what Magritte's surviving relatives and friends have said, the titles sometimes came about through Magritte's own invention, but also very often through discussions with others, at soirées, on the telephone, or in letters, when a painting would be made the subject of discussion. Magritte's circle of friends did not consist of painters but of intellectuals and well-read people (lawyers and the like), almost all of whom had some literary leanings or gift and had played a part in the Surrealist movement in Belgian writing. Almost all of them had written poems, essays, or aphorisms; the circle included Paul Colinet, Camille Goemans, Louis Scu-

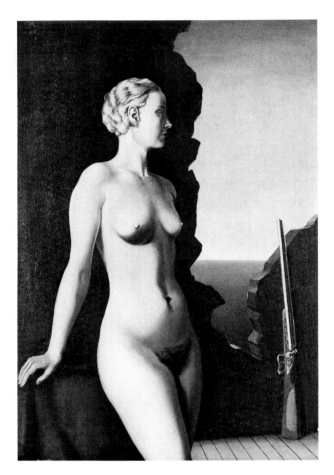

24. THE LIFELINE. *La Ligne de vie (La Femme au fusil).* 1930. Oil on canvas, 28⅜ x 20⅝".
Private collection, Osaka

itself, and are therefore important. Moreover, the titles, although evoked by the paintings, seem to be able to exist separately, parallel to the paintings. Their character, at times provocative, lies in their strange relationship to the painted image. Magritte's intense concern with titles, and particularly with a change in their function, which is what he was aiming for, is, as far as I know, unique.

Of what did Magritte's rules consist? Magritte has never provided us with a full account, but throughout his life he repeated, with variations, what he was aiming at with his works and their titles. He did this in brief, almost aphoristic sentences in which he was apparently trying himself out. What he sought was to put new life into our tired view of the ordinary

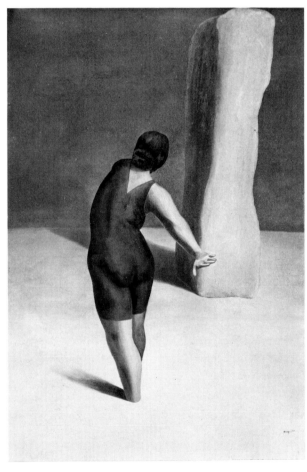

25. THE SCENT OF THE COUNTRYSIDE LURES THEM ON. *L'Odeur de la campagne les fait avancer.* Before 1930. Oil on canvas. *Whereabouts unknown.* (Magritte wrote on the back of the photograph: *"Titre mauvais. Bon titre à trouver"* [Bad title. Good title to be found].)

tenaire, Marcel Lecomte, Paul Nougé, E. L. T. Mesens, and Pierre Crowet.

In Magritte's letters (in the Archives des Musées Royaux in Brussels), which are often difficult to date, one repeatedly comes across remarks which indicate intense activity on his part to find good titles—with the help of one or more friends. In letter No. 8905 he is complimenting Lecomte on his splendid find. In letter No. 9554 he writes that *"Le réveil matin"* *(The Morning Awakening)* will do for a title, "if a better one is not found. If you are stimulated by the idea of research, you will no doubt supply me with a more ingenious title than the one we have for this painting." He was demanding, and his poets, among whom Nougé deserves special mention, were there to serve him.

Magritte repeatedly drew up new rules with which the titles had to comply. These rules are based on his concept of the nature and function of the painting

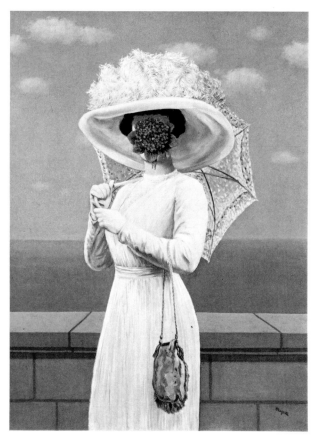

26. THE GREAT WAR. *La Grande Guerre*. 1964.
Oil on canvas, 31⅞ x 23½". *Veranneman
Foundation, Kruishouten, Belgium*

order to be given to a painting. The poetic title has nothing to teach us; instead it should surprise and enchant us.

Again and again Magritte resisted explanatory titles, and from a public which has been brought up in the tradition of titles that point the way for them this demands a mental effort in a new direction. In Magritte's titles there is nothing to be understood—at least, not in the classical manner, which since the seventeenth century has used language to represent ideas, especially through commentaries, and to elucidate the concealed content of pictures or texts.

Magritte was opposed to hidden or symbolic content. To an extent, commentaries presuppose that there can be a substitute for the image in the form of interpretive texts—or at least that the image is translatable into words. Since Magritte was thinking only of rendering ideas *visible* by painting, he rightly laid the emphasis on "the visible" and defended it vis-à-vis "the invisible."

Whereas Magritte rejected the explanatory function in painting, he recognized it without reservation in ideas. "It is the idea which permits an 'explanation.' It is from the idea that it derives its value.

things of existence, which, precisely because our view of them was tired, had become practically invisible. He wanted to restore our initial wonder at things.

In an unpublished, undated paper in Georgette Magritte's possession, he summarizes his poetic attitude under the heading *"Question du titre"*:

I think the best title for a painting is a poetic title. In other words, a title compatible with the more or less lively emotion which we feel when looking at a painting. I imagine it requires inspiration to find this title. A poetic title is not a sort of indication which tells one, for instance, the name of a town whose panorama the painting represents or the symbolic role attributed to a painted figure. A title which has this indicative function does not require any inspiration in

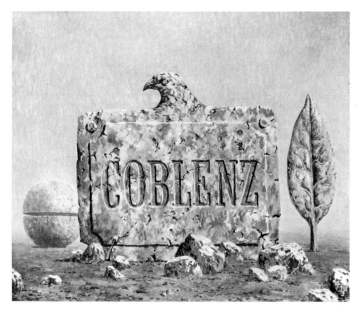

27. THE FOUNTAIN OF YOUTH. *La Fontaine de jouvence*. 1957.
Oil on canvas, 19¼ x 23½". *Collection Rudolf Zwirner, Cologne*

Whether the explanation is of a theological, metaphysical, psychological, or biological nature, it is emitted by the idea which explains without ever explaining itself, however it may seem."[12]

In any case Magritte attacked the old supremacy of the written word. He did what no painter before him had done, at least not in this strange and rare combination of intuition and critical analysis regarding the origins of pictures and language in relation to thought. Both by his paintings and by his titles (in a dual mental activity) Magritte separated the names from the objects and made the observer of his work aware of the enormous gulf between the dominant convention of words and the true significance of things. He generated a shock, not by a trick or a capricious fantasy, but through the analytical imagination. In his case we ought to keep fantasy and imagination strictly apart. In reality it is all a consequence of a process which had already begun during the seventeenth century—the rift between what could be seen and what could be read, the beginning of distinctions among the observing eye, the listening ear, and the writing hand.

Among the finest examples of the relation between word and image during the seventeenth century, long before Magritte in the twentieth century arrived at his deliberate alteration of the function of title and painting, are the two celebrated paintings by Nicolas Poussin known as *The Shepherds of Arcadia,* the earlier one (1629–30) from the collection at Chatsworth, the later one (1639–40) in the Louvre. The title acquires its rather cryptic touch only as a result of the inscription Poussin painted on the tombstone in the painting, "ET IN ARCADIA EGO," which gives the viewer a shock of doubt regarding the usual concept of immortality in Arcadia.

Educated in the celebrated Age of Reason and equipped with a considerable humanist culture based on reading, Poussin saw a chance of confronting his learned interpreters with problems. He was indeed basing himself on books he had read, but at the time he added an invention of his own in order to bring about a transformation in his mythical subject matter. It becomes clear from the iconological treatment of his themes that, in the process of paint-

ing, what has been read yields place to the task of making things visible, and the subject sometimes comes across in a deformed manner. Actually, what has happened is that here the explanatory function of a title has been shifted to a text which has been absorbed into the picture and the title is no longer, therefore, a title in the usual sense.

There was, thus, an uncomfortable gap—not only for Poussin himself but for those who looked at his pictures too—between what is read and what is seen, and the learned interpreters attempted to bridge this gap by humanist means in which—perhaps involuntarily but in any event very obviously—the word, and therefore the mind, was dominant.

During the nineteenth century Impressionism defined its titles (which were actually superfluous, as Magritte was later to remark) by a general reference to what can be readily seen in the paintings; examples are *Women in a Garden; Woman in a Green Dress; Gare Saint-Lazare; Luncheon on the Grass; Poplars.* Even in 1874, when the term "impression" began to be used, something like interpretation seemed to be emerging, although the addition of words like "mist," "rising sun," and "setting sun" sends us back to the realities of nature once again.

It was Whistler, with his titles from 1864 on, who abandoned the conventional and employed the poetic, evocative quality of transparent words in musical captions which no longer named the objects in his works but their actual properties—*Portrait of the Artist's Mother (Arrangement in Black and Gray, No. 1); The Little White Girl (Symphony in White, No. 2).* Here, in the subtitle, we see the beginning, not of explanation, not of interpretation, but of *pictorial analysis* through a poetic evocation. There was a switch of emphasis and, as is common knowledge this was immediately felt to be an insult in the English art world, as was shown by the court case between Ruskin and Whistler in 1878. This drama has lost its anecdotal appeal by now, even though the conflict and the court case were catastrophic for Whistler, but what is important is Ruskin's refusal to *see,* irritated as he was by the *words,* which do not point to a legible concept but to qualities of seeing.

In the twentieth century the change in the func-

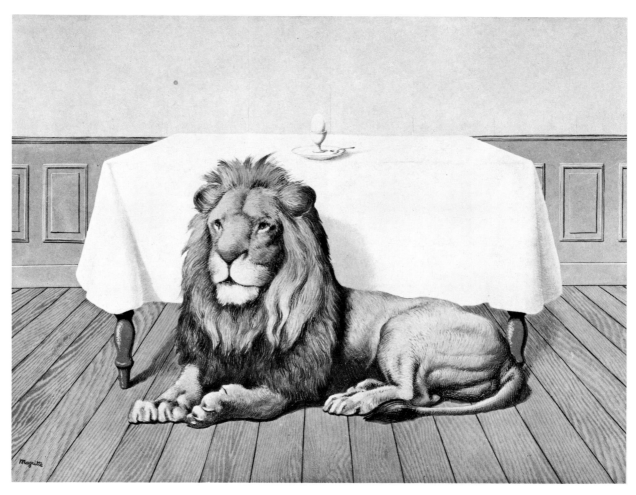

28. THE WEDDING BREAKFAST. *Le Repas de noces.* 1940, Gouache, 12⅜ x 16½". *Private collection, France.*
(Painted at Carcassonne during the exodus from Belgium to France at the beginning of the war.
First title [rejected]: *Le Voyage.*)

tion of the title that had begun with Whistler, by which it indicated areas other than the figuration, continued in two streams. Abstract art, with Kandinsky at the fore, found the terms "composition" or "improvisation" useful. "Composition" arrived at its obvious final form with "untitled," which is still used by artists today who, by employing it, completely accept the rift between image and word and seek to stimulate in the public the capacity to absorb things without words acting as an intermediary. Later, the other possibility opened up by Whistler was that adopted by the Surrealists (Ernst, Arp, Dali, Tanguy, Magritte). Of these, Magritte was the most doctrinaire, and no one attached as much importance as he did to finding and defining the words which come in the wake of an image.

The cryptic constituent in Magritte's titles implies a radical change in their function. His particular difficulty proved to be that severing the logical connection between the word and the image had to allow for a link which was no longer logical, interpretive, or explanatory, but which depended on "visible poetry," on "thinking painting," although not literary thinking. Perhaps Paul Nougé came closest to this by looking for the genesis of Magritte's pictures in a mental force *(puissance mentale)* which has been active since the dawn of history (see the 1954 Brussels catalogue).

With Impressionism, "optical culture" had arrived at a maximum of expression, with divisionism as its system and with analysis as its basis. At the same time it had torn itself free from "written cul-

ture"; a symptom of this was the neutrality of the titles. From 1926 on Magritte tried to deepen "the tradition of the seen," to pour new life into it, to lead back what had become worn and threadbare to the original sense of wonder present at its birth. He sought to unite the visible content with titles of literary inspiration. The ambivalence of this lay in his trying at the same time to suppress every literary, analytical, and symbolic explanation of the titles.

Magritte and the Linguists

Words began to appear in Magritte's paintings about 1928—in any case, during his Paris period from 1927 to 1930. The process can be associated with outline forms such as those appearing as early as 1926, although *without* words to begin with. Magritte noted that "there are objects which do without a name."[13] For this, see *The Prisoner* of 1926 (fig. 29).

The forms in *The Prisoner* amount to irregular white fields within roughly hewn wooden frames. It is impossible to imagine what they are; they occur time and time again. During 1927 Magritte painted objects (a hat, mirror, bird, bow tie, apple, candle) in similar irregular fields, but without enclosing them within frames (see *The Reckless Sleeper* of 1927, fig. 5).

In 1928 the rather broad frame reappeared. That year Magritte made *The Demon of Perversity*, which contains a fanciful shape with openings in it, behind which can be seen wooden planks with expressive grain painted with great subtlety. The fields enclosed by these frames are no longer white, and they contain representations. For instance, in *The Change of Colors* of 1928, there are clouds in a blue sky on the left and nocturnal darkness on the right. *The Proper Meaning IV* of 1928–29 displays on a white, framed, and circular field the words *"femme triste,"* and in *This is Not a Pipe* of 1928–29, the painting of a pipe, which Magritte repeated with variations several times, bears the words *"Ceci n'est pas une pipe"* (This is not a pipe). In these years,

1928–29, Magritte used countless words in his paintings.[14]

A related deep relief is to be seen in Salvador Dali's *The Enigma of Desire* (1929), with its subtitle *Ma mère, ma mère, ma mère,* which too is an inscription painted into the work. It conjures up associations with the ornamental sculpture of Gaudí, whom Dali so much admired. Others see a connection with features of erosion in coastal rocks, but the form is too stylized for this. Dali paints erosion with a realistic precision. The words *"ma mère, ma mère, ma mère"* come from Tristan Tzara's first volume of poems, *La Grande Complainte de mon obscurité,* of 1920, and provide a suitable case for a psychoanalytical approach. Compared with Dali's work, the writing in of words in Magritte's art has a different aim and a different history behind it, but the two artists may have been aware of the effect of words in each other's paintings.

In 1929 Magritte and his wife, accompanied by Camille Goemans and Marcel Lecomte, were at Dali's in Cadaqués and remained there for five weeks. Paul Eluard was there too, with his wife Gala and their daughter, Cécile. These were emotional and consequential encounters, since Gala and Dali fell so much in love that they resolved to stay together. It was, at all events, something more than a superficial mutual encounter between Dali and Magritte. Magritte's contacts with Joan Miró, however, which some have mentioned, seem negligible to me; they were, at least, cool on both sides.

The use of letters and words in paintings in the twentieth century began with Braque, in 1909. In 1911 both he and Picasso were using them with great emphasis, not merely as a compositional element but, as Douglas Cooper has put it, "with an associative relevance to the subject of the picture, so that they contributed to the realism of the picture."[15] The invention of *papiers collés* and collage increased the use of words or titles still further, with various aims. In the 1920s, the budding Surrealists Max Ernst and Joan Miró also used them, both lyrically and poetically.

When the Surrealist vision began to emerge in his work during the 1925–26 period, Magritte made a

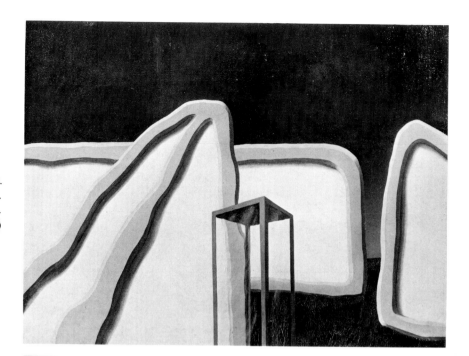

29. THE PRISONER. *Le Prisonnier.*
1926. Oil on canvas, 21¼ x 28¾".
Collection Mme Jean Krebs, Brussels.
(Nondescript forms without words.)

30. LIVING MIRROR. *Miroir vivant.*
1926. Oil on canvas, 21¼ x 28⅜".
Collection Mme S. Binder, Brussels.
(Connected indefinite spots with
inscribed names.)

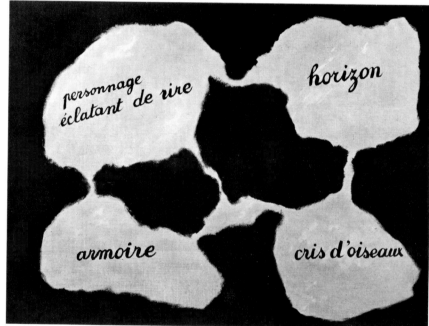

31. THE USE OF WORDS I.
L'Usage de la parole I. 1928–29.
Oil on canvas, 21¼ x 28¾".
*Formerly Collection Mme Jean Krebs,
Brussels.* (Nondescript forms with
shadows and names of precise things.)

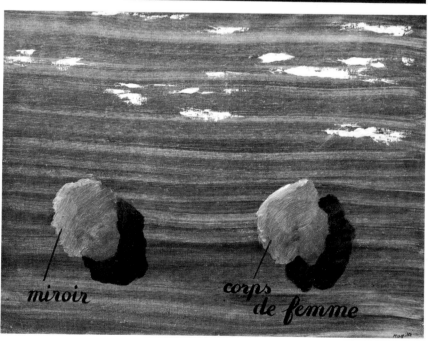

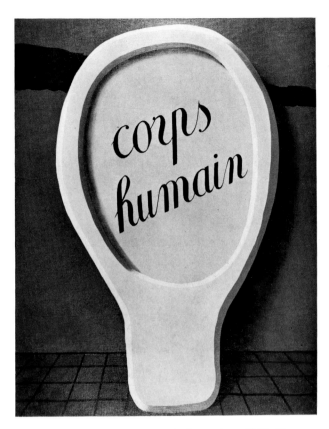

32. THE MAGICAL MIRROR. *Le Miroir magique.* 1928–29.
Oil on canvas, 29 x 21½". *Collection L. Monti, Milan.*
(Object with inscribed name designating itself.)

more figurative use of the collage, but in 1928, as soon as he realized what he could do in the given situation, he invented a totally original way of working. The nameless forms he then made bore words whose usual meaning became doubtful and problematical in the special context he created for them. The relationship he established between a nameless form and a noun removed both form and noun from the world of names.

Suzi Gablik, in her study of Magritte, has rightly seen that there is a remarkable connection between Wittgenstein's philosophical linguistic writings and Magritte's texts and those paintings which incorporate words. Both men sought to demonstrate the *relative* nature of our use of words. There is no logical connection between what an object is and the name it has acquired; the name does not represent what the thing *actually* is. Freed from their customary names, objects return to their origins, to a state prior to being recorded in the various language groups. Language becomes divorced from its classical certainty.

Magritte remains first a painter, however, and his intuitive insights about language and words were always directed toward defining the function he was seeking for his painting. He recorded these insights in relation to the "images" in his paintings, and when he did this he was not yet aware of modern linguistics. It was only much later, during the 1960s, that he enthusiastically read Michel Foucault's *Les Mots et les choses* (which is still in Magritte's library), noticing that an unconscious connection existed between his own activities as a Surrealist painter and the activities of linguistic philosophers like Foucault.

What is surprising is that Magritte and Foucault should have discovered each other in the same period. One sentence alone, in a letter addressed to Marcel Lecomte[16]—in which Magritte writes that he is reading a splendid book, *Les Mots et les choses*, by Foucault—has confirmed my feeling that an affinity of thought existed between the two men which is difficult to explain but present nevertheless. This substantiation was reinforced by the discovery of another book by Foucault, on Raymond Roussel, in which Foucault had written a flattering inscription for Magritte. What he wrote is highly interesting: "For Monsieur René Magritte, this book by the fellow creature to the Likeness and more particularly as a token of admiration. M. Foucault."[17]

The two men even exchanged letters for a while, and Foucault wrote a long essay[18] in which he analyzed Magritte's mental processes, guessing at the meaning and origin of his *Ceci n'est pas une pipe* series of paintings. Foucault analyzed minutely a whole host of interpretations of this series, made possible by Magritte's method of including words and an "image" of an object in the same context, in paint. The words and the image conflict with each other with devastating effect, and the commonplace idea of a pipe evaporates.

Suzi Gablik, unaware at first of the relationship between Magritte and Foucault, was nevertheless right when she quoted from Wittgenstein (who was unknown to Magritte)—from *The Blue and Brown Books* and *Philosophical Investigations.* To these we can add the *Notebooks 1914–1916,* in which, feeling

his way as he goes along, accepting here and rejecting there, Wittgenstein makes remarkable pronouncements on images, things, words, and language, among reflections comprehensible only to the trained mathematician—for example, "The picture can replace a description."[19]

In Magritte's writings we find the following: "Sometimes the name of an object replaces an image. A word can replace an object in real life. An image can replace a word in a proposition."[20] And Wittgenstein writes, "It can never express the common characteristic of two objects that we designate them by the same name but otherwise by two different ways of designation, for, since names are arbitrary, we might also choose different names, and where, then, would be the common element in the designations?...It is to be remembered that names are not things but classes: 'A' is the same letter as 'A.' "[21]

Now that Wittgenstein and Foucault have been mentioned, the writings of an earlier pioneer linguist, Ferdinand de Saussure, who has been discovered since the 1950s, should be quoted too. We must rate the quality and originality of Magritte's unschooled thinking high indeed, when we find that a number of points he looked upon as fundamental come very close to some of Saussure's pronouncements, which are pre-Wittgenstein.

What were these fundamental points? We can trace how, in the 1920s, Magritte drew nearer to his goal, progressing step by step, clearing away the things he did not care for. The Cubist, Futurist, and abstract avant-garde, which had won fame during the twenties, had offered sufficient material for years, but about 1925, dissatisfied with the means at his disposal, Magritte realized the true nature of his mental and physical reactions to the world. He discovered subject matter which could not be portrayed by the means the avant-garde had to offer. Seeing a relationship with the work of Giorgio de Chirico and with Max Ernst's production in the 1921–24 period had a

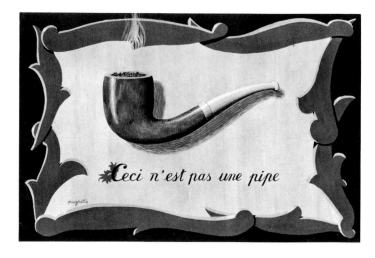

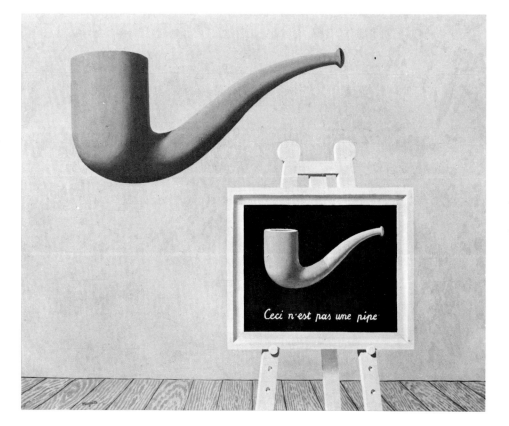

above: 33. THE AIR AND THE SONG. *L'Air et la chanson.* 1964. Gouache, 13¾ x 21¼". *Private collection.* (Belongs to the series *Ceci n'est pas une pipe.*)

left: 34. THE TWO MYSTERIES. *Les Deux Mystères.* 1966. Oil on canvas, 25½ x 31½". *Private collection.* (Belongs to the series *Ceci n'est pas une pipe.*)

stimulating effect on him then. For years an important feature of De Chirico's work was his juxtaposition of objects which were outwardly alien to one another, not through reasoning but by feeling—a mechanism of feeling—while at the same time making use of surreal alterations of scale, the whole being set in half-imaginary, half-real landscapes and city squares, usually in a depressing and oppressive atmosphere.

This was something Magritte instinctively understood. He then discovered his own "climate," not so much among the painters as among the rising generation of Belgian Surrealist writers. It is impossible to exaggerate the importance of these authors, because of the quality of their work and also because they are a main source for getting to understand Magritte. In view of the contacts these authors had with the artists grouped around André Breton and Tristan Tzara in Paris, it is not surprising that Magritte should also have come into touch with them, since he himself lived near Paris for three years.

All that can be said here about this, without going into the matter deeply, is that Magritte's urge to paint was of a dualistic nature, and that this dualism is perceivable in his imagination, which was both acoustic and visual. The picture of the world which composed itself time and again in Magritte's mind came into being along these two paths. The fusion of the acoustic with the visual resulted in the "image."

The term "acoustic" embraces more than is conveyed by the terms "words," "language," or "literature." It refers to both music and words, the basis of which is, indeed, acoustic, according to the linguists. Moreover, the first acoustic-visual impulse involves not only the works in which words actually appear but also those in which no words are visible.

Magritte saw shapes, but at the same time heard the words by which they live on as objects in men's minds. Gradually the words became clearer, and at the same time his critical consciousness separated them from the objects. His problem was the conflict between two evocative elements—things and words. This is not to say, though, that there was no interplay between Magritte's consciousness of words and his consciousness of things seen, although this was unformulated and merely latent at the outset.

Psychologically, sound was highly significant to Magritte. He was a melomaniac, and was fond of listening to music when he was at work. He often had music by Brahms and others played to him; at his wish, Georgette had to play the piano for him. An admirer of Mallarmé, Magritte must have found that author's work all the more attractive because of the musicality in both the poetry and the prose.

He began to cast doubt on both the image and the word—seen, heard, or read—and showed this by means of his investigations. The color of a woman's body or of an apple may, without objection, be replaced in the painting by one different from the customary one. A word used for an object may be another word too. The object may be replaced by a word. Interchangeability and replaceability destroy the credibility of the established signs on either side.

It is here that remarkable resemblances are to be found between concepts in the philosophical and linguistic lectures of Ferdinand de Saussure and Magritte's discoveries in painting. A few quotations from Saussure, read in conjunction with the mechanism at work in Magritte, are sufficient indication of this: "The link uniting that which signifies (the acoustic image) with what is signified (the concept) is arbitrary, or again, since we understand by means of a sign, that is, the total resulting from the association of a signifier with the signified, we may say more simply: *the linguistic sign is arbitrary*. Thus the idea *soeur* (sister) has no intrinsic link with the succession of sounds (s-ö-r) which serves to signify it; it could just as well be represented by any other sign...which is proved by the difference existing between languages and by the very existence of different languages...."

Saussure also wrote, "...linguistic unity is a duality, the result of the meeting of two terms.

"We have seen, regarding the circuit of the word, that the terms implied in the linguistic sign are both mental, and both are united in our brains by the link of association....

"*The linguistic sign does not unite a thing with a name*, but a concept with an acoustic image. The latter is not the actual sound, which is a purely phys-

ical thing, but the mental impression made by this sound, the representation provided by the testimony of our senses...."[22]

This makes it abundantly clear how special Magritte's position among the Surrealist painters is, differing from that of Ernst, Dali, and Tanguy. He introduced into painting elements which changed the painting's *function*. This is one of the reasons why we cannot achieve very much by approaching his work via the traditional descriptive method of the art historian or aesthetic analysis.

"Unthought-like Thoughts"

When, in 1965, Magritte visited New York for the first and last time, for a major exhibition of his work at The Museum of Modern Art, the art world there gave him a spectacular, lavish, and typically American reception—insofar, that is, as it was aware what Surrealism signified. Magritte did not, however, allow himself to be deflected from his purpose. As the art critic Dore Ashton informed me, "One of the first sightseeing excursions (and perhaps the only one) was to Poe's house.... His biggest association with my city was Edgar Allan Poe."

This was confirmed by those who accompanied him on the visit; Magritte, they told me, was moved, and his veneration for Poe must have been very deeply rooted. His pilgrimage to the place where Poe had lived and worked indicated the inner bond which had developed between himself and the American author since the 1920s, when people started searching for the nineteenth-century forebears of the Surrealist idea and attitude to life.

Loosely formulated, Magritte's recurrent interest in Poe's *Tales of Mystery and Imagination* could be largely explained by the intellectual, quasi-philosophical, and psychological observations to be found in them, couched in the polished literary and musical style with which Poe used to present all his ingenious and sinister mysteries and fantasies. Unusual fantasy landscapes, extraordinary events, abnormal

behavior, perversion, insanity, a passion for gambling, intoxication, crime—all these were analyzed. A dominant feature was the undertone of death—about to occur, occurring, or having already occurred—which overstepped all previous limits by even including imaginary experiences after death. Bizarre and horrible stories featuring coffins alternated with remarkable dialogues across the frontier of life and death (as in the stories "The Premature Burial," "The Colloquy of Monos and Una," "Some Words with a Mummy," "The Conversation of Eiros and Charmion," "The Oblong Box"). Moreover, Magritte's youthful experiences—such as the suicide of his mother (who drowned herself in the river at night and was found with her nightdress covering her head), his experiences in churchyards, his later macabre experiments with coffins (described in the commentary on *Perspective: The Balcony by Manet*, colorplate 31)—point to deep affinities with Poe.

Magritte's visit to Poe's house was a visit to the Other—to his own darkness, his own shadow, emerging beyond his self-knowledge and his conscious self. He built up a genuine philosophy out of Poe's writings, even though a literary one. Into this philosophy enlightened remarks about man and about life and death are woven which are not mere reflections but also involve the imagination. One of these—even in its unelaborated form—is fundamental to an anti-classical line of thought in the nineteenth century, which confronts the nonthought, or everything that falls outside the confines of thought formulated in signs and words.

In an untitled love poem, dedicated to Miss Marie Louise Shew, Poe begins with the classic lines:

Not long ago, the writer of these lines,
In the mad pride of intellectuality,
Maintained "the power of words"—denied that ever
A thought arose within the human brain,
Beyond the utterance of the human tongue.

But "the power of words" weakens under the pressure of

Unthought-like thoughts that are the souls of
 thought,
Richer, far wilder, far diviner visions
Than even the seraph harper, Israfel,
(Who has "the sweetest voice of all God's
 creatures,")
Could hope to utter.

It is, Poe goes on to say, not speech, not thought, not feeling:

This standing motionless upon the golden
Threshold of the wide-open gate of dreams.

"Unthought-like thoughts"—it is this which comes down to us through the nineteenth century, like a flash of poetic philosophic intuition that never fails to shock us, a ferment which undermines logic.

Poe was not sufficiently a thinker to work it out further, beyond the limits of poetry. His essays "The Poetic Principle," "The Rationale of Verse," and "The Philosophy of Composition" are restricted in his already modern-sounding analysis of poetic technique to a plea for consciously calculated means and effect, although he does not fail to mention, even if only in passing, the importance of "some amount of complexity" and of "some undercurrent, however indefinite, of meaning." In his prose, Poe speaks of "the poetic intellect—that intellect which we now feel to have been the most exalted of all—since those truths which to us were of the most enduring importance could only be reacted to by that *analogy* which speaks in proof-tones to the imagination alone, and to the unaided reason bears no weight" ("The Colloquy of Monos and Una"). Poe held on, with talent, to the rational, in opposition to which a measure of anxiety, terror, astonishment, and disgust appertaining to his own being manifested itself, in which both the irrational and the unthought were present.

The "poetic intellect" can be detected in Magritte's imagination too. It plays a part in the technique he evolved in discovering hidden affinities between widely divergent phenomena, the source of a great number of his "images." This does not alter the fact that the basis of everything is nevertheless a venture into areas little explored, or at least not consciously explored, until then and referred to in one context as the unconscious and in another as the unthought—the "unthought-like thoughts" Michel

35. THE SKY PASSES IN THE AIR.
Le Ciel passe dans l'air.
Oil on canvas, 25½ x 31½".
Whereabouts unknown

36. THE TASTE OF THE INVISIBLE. *Le Goût de l'invisible.* 1928. Oil on canvas, 29 x 39″. (The definite forms have a resemblance to paintings by Joseph Sima [1891–1970], who was very active in Paris in 1926–32.)

Foucault refers to in his masterly essays, where he writes, "All modern thought is penetrated by the law of thinking of the unthought-of."[23]

Foucault sees that modern man's thinking about himself is concerned increasingly with the Other One, the one who is the Stranger and the Dark Companion. That which is unthought, and which until recently eluded man, becomes a factor in ever more urgent questions about the possibility of a life and existence no longer entirely covered by words and thoughts. The task is to lift the veil lying over the unconscious, to lose oneself in silence, or to listen to its vague whispers.

In "The Man of the Crowd" Poe created figures belonging to "the tribe of clerks," who are forerunners of the nineteenth- and twentieth-century bourgeois, with his ready-made clothes and bowler hat, as depicted by Magritte: the strikingly unstriking figure, temporarily singled out from the crowd without

which he is inconceivable. In this case the art historian can say that at least five painters anticipated Magritte in presenting the type, with or without hat; they were De Pisis (1919), Carrà (1916), in a rather more emphatic manner Giorgio de Chirico with *The Child's Brain* (1914, fig. 13), George Grosz with *Republican Automatons* (1920), and particularly Max Ernst with *Pietà or Revolution by Night* (1923, fig. 14).

No one mastered the theme of this figure as well as Magritte. In the absence of a catalogue of his complete oeuvre it is impossible to say how many times he treated it, but, excluding the drawings, I have noted at least twenty-five wearers of bowler hats. Only four of these twenty-five were painted between 1926 and 1929.

In the first issue of *Variétés*, dated May 15, 1928, there is an illustration of a small man in a bowler hat on the beach, shown both from the front and from

40. THE SONG OF THE VIOLET. *Le Chant de la violette.* 1951. Oil on canvas, 39½ x 31⅞"

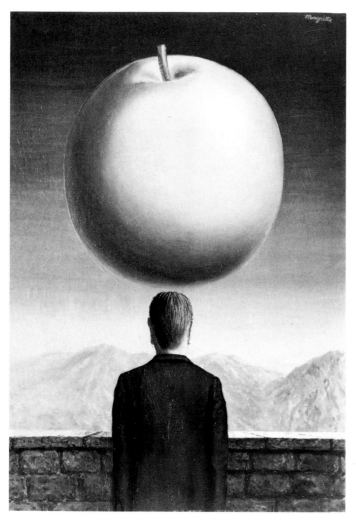

41. THE POSTCARD. *La Carte postale*. 1960.
Oil on canvas, 27½ x 19½″. *Private collection*

which made him decide to ignore logic and show us not his face in the mirror, but his back. Next to him lies the French edition of Edgar Allan Poe's *The Mystery of Arthur Pym*.

In Magritte's painting of a frontal view of James (fig. 39), shown in the dark, with the fingers of his right hand on a table as if at a spiritualist séance, the face has been absorbed by (or has exploded to become) a ball of radiant light which reaches as far as the shoulders and chest; on the table lies a stone bearing traces of corrosion. The title reads *The Pleasure Principle*. In both portraits we see an ultra-individual—the very antithesis of "the man of the crowd"—who is the unfamiliar and mysterious Edward James, and whom no one gets to see. Just as

Magritte succeeded in keeping James's face hidden from us, so, in daily life, he succeeded in keeping his own face, the face of an artist, hidden from people in his way of life, adapted as it was to bourgeois society.

He took this secrecy so far as to refuse to have a separate studio. He painted anywhere it suited him—in his living room, his drawing room, the kitchen, the bedroom. This attitude fits logically with the picture of "the man of the crowd," busy preparing the dynamite of his inventions unobserved by the world, not laying any emphasis on painting and acting in this way not in order to conform, but to camouflage his activity.

It has been too little emphasized that, in common with other Surrealists, Magritte dreamed of a future society which was different from and better than the one he was doomed to live in, without being able to accept it. From as early as 1926 and especially during the three-year period 1930–33, the problems of leftist artistic involvement were a subject of heated discussion among artists, being treated almost systematically in periodical form in *Le Surréalisme au service de la Révolution,* under the direction of André Breton. Actually, the militant Communists distrusted the revolutionary Surrealists, and the latter in turn—taking sides in the Stalin-Trotsky controversy—usually favored Trotsky, not wishing to conform to the dictates of the party leadership.

It was once again Paul Nougé who, in No. 5, the issue of May 15, 1933, of *Le Surréalisme au service de la Révolution,* took up the case against abstract art and for Magritte; in "Les Images défendues" he pleaded for the new "seeing," which was not mere "looking." The battle, which was more than aesthetic, was waged with utter conviction.

In 1934 Magritte, E. L. T. Mesens, Paul Nougé, Louis Scutenaire, and André Souris signed *"L'Action immédiate"* at the top of *Intervention surréaliste* (*Documents 34*, No. 1, June). The magazine gave vehement expression to its deep alarm at the growing power of the Fascists. The five Belgians who appended their signatures wanted to carry on a poetic revolutionary campaign independent of the one prescribed by the Communist Party, which would involve people in unfamiliar experiences, allow them

to hear unexpected words, and break down the barriers around their thinking. Yet, they were aware that their aims would be judged naive and coarse.

Magritte projected the image of "the man of the crowd," particularly the bowler-hatted man. He was usually a solitary figure, but sometimes appeared in duplicate. Multiples of him occurred only seldom; the repetition of him signified the crowd. In *Golconda* Magritte projected these small gentlemen en masse, rising up into the sky, which they silently occupy like an obsessive swarm.

It was only rarely that Magritte surrendered to a single impression, vision, or idea in his paintings. Almost always his intellect, fertile as it was with associations and comparisons, interrupted the poetic emotion, which is by nature susceptible to such intervention and for the same reason also vulnerable. This intervention explains why the ultimate image is neither thought nor feeling; it is incomplete—incomplete also as an image, remaining difficult to define, both in the classical and in the romantic sense.

The intervention in the forming of an image in Magritte's work results from an awareness of the Other, or the Other Person, which in him is more frequent and greater than in most of us.

"Unthought-like thoughts" remains, in my opinion, the best term to summarize these indefinite image-thought features which in Magritte's work are the product—not in the form of ideas but in the form of visible images—of his great powers of observation and assimilation.

The Hidden Affinity Between Magritte and Coleridge

The existence of an affinity between Magritte and Samuel Taylor Coleridge is not so farfetched as it may seem. Magritte had not read a word by the celebrated English poet and philosopher of the Romantic era, yet his imagination was analogous in structure to that of Coleridge. Since Coleridge was a poet trained in theology and philosophy, having links with the idealist German philosophers of his day, while Magritte was a twentieth-century Belgian painter untrained in philosophy and literature though with a pronounced interest in both—he read Hegel in French translation, Fichte, Heidegger, and others—some spark had to leap across the gap between the two before contact could be made.

This spark was generated by Edgar Allan Poe, whose influence on Magritte was, as I have shown, deeper than that of any of his favorite contemporary or near-contemporary authors, such as Lautréamont (Isidore Ducasse), Villiers de L'Isle-Adam, Mallarmé, Valéry, and Roussel. "Poe's adherence to Coleridge's design was almost slavish,..." concludes the percipient analyst Edward H. Davidson.[24] Magritte's adherence to Poe, on the other hand, certainly did not amount to enslavement, yet he had read not only Poe's *Tales of Mystery and Imagination* but, as his correspondence with his friends among the Belgian Surrealists shows, the far less widely read and certainly not popular essays on theoretical subjects, such as "The Poetic Principle," "The Philosophy of Composition," and "The Rationale of Verse" as well. The philosophical dialogues on life and death ("The Colloquy of Monos and Una" and "The Conversation of Eiros and Charmion") he had made his own.

So, without being aware of it, Magritte had learned certain of Coleridge's fundamental ideas, as woven by Poe into his own subject matter and thinking. Magritte's involvement with Poe was more than making the poet's acquaintance out of interest and curiosity, however, and rather a case of recognizing himself in Poe; it was also a matter of seeing certain ideas evolved by an analogous poetic intellect. It confirms that Magritte's spiritual family tree is the same as that of Coleridge, Wordsworth, and Poe, some of whose roots lay in the soil of the German idealist Romantic poetry and philosophy. Poe was no mere duplicate of Coleridge—he stood at the end of the Romantic era, in its hour of crisis. Like all the pioneers of Surrealism, Magritte was obliged to decide on his attitude not simply toward spiritual and aesthetic beliefs but also toward the Communist political line, and he had heard of Hegel's dialectics from these political quarters. He was an avid reader

of Villiers de L'Isle-Adam and in this author's work, too, he encountered Hegel's influence, among that of others.

Magritte's independence of spirit in his painting was accompanied by a critical reserve toward much that came his way. His strength of character was proved by his having successfully resisted so influential a force as André Breton—a man with all the characteristics of a leader—during the years he spent as a young man in Paris. While there, he refrained, as a matter of principle, from associating himself with various aspects of the Surrealist trend. Between 1920 and 1925, for example, he was very much engrossed in Max Ernst's work, as is shown by the small painting with a hand and a small bird of 1925 (fig. 2). This work was inspired, as Félix Labisse has informed me, by the illustration of a wall painting Max Ernst had made in 1922 for Paul Eluard's home in Eaubonne. When Magritte bade a firm farewell to Cubism and Futurism, Ernst, an ambivalent Surrealist, on the other hand, continued to draw fruitfully both on those sources and on Surrealism. In Ernst's work, the fantasy, or fancy, is richer than the imagination, whereas in Magritte the imagination is dominant.

The distinction between "fancy" and "imagination," dear to Magritte's heart too, was developed by Coleridge, who rated imagination higher than fancy, considering the latter a faculty of mind which operates whimsically, capriciously, and unsystematically in shaping illusory, fantastic, or false images and combinations of extravagant things. The imagination, however, creates mental images of things observed earlier or of things unexperienced or even nonexistent, and it is also the driving force which distorts the images of things through comparisons or combines them in new ways.

Baudelaire was delighted when, in 1859, he found he was able to quote Coleridge in confirmation of his own ideas,[25] such as the following passage by the English poet: "By imagination I do not simply mean to convey the common notion implied by that much abused word, which is only fancy, but the *constructive* imagination, which is a much higher function."

Baudelaire translated "constructive imagination"

as *"imagination créatrice."* It is misleading that the art critics and organizers of exhibitions continue even today to pigeonhole Magritte's work as "fantastic art," ignoring Coleridge's long-established distinction. Magritte himself was convinced that the source of the greater part of his work was not the faculty of fancy but that of the *"imagination créatrice."*

Magritte's strength lay in his ability to create *visible poetry* as the result of an inspired idea—that is, the sort of idea which creates an order where mystery is evoked. Without mystery, neither the world nor the idea is possible, according to Magritte. In addition, he made a fine distinction, not always to be found in the dictionary, between *la ressemblance* and *la similitude*, preferring the former.

The key to Magritte's process in his work is that he was creatively engaged in making comparisons. For comparisons to be made the memory has to be brought into play, and it is the creative imagination which then discovers and reveals the secret and hidden resemblances between what is called *la différence* (states of being different), the Other, and the Other One. Thus the essence of Magritte's activity as a painter is the liberation of things from their confining, misleading names and from their social, moral, and linguistic history, in order to present them mysteriously, as new, original, and restored to their earliest state. It was this that made him a pioneer in the world of painting. His aim is bound up with what Henri Michaux so poetically called "unveiling the normal, the unrecognized, the unsuspected. the incredible, the normal enormity."[26]

Already during the nineteenth century a process was under way in philosophy, literature, and science which signified a breach with the seventeenth-century's conviction that what we read and what we see are one and the same thing. Analytical thinking founded on reason leaves the irrational unexplored. Magritte's art shatters the self-assurance of reason and the identification of the representation with its content, thereby also rendering the representation of space labile; thus he introduces doubt as a fermenting force into the visual aspect of painting.

Cubism and Futurism introduced a new perspec-

tive but continued to mix objects and their settings, which interpenetrated in space. Magritte reintroduced comparisons, not outward but inward comparisons, and in doing so he revived the sixteenth-century practice of arriving at a knowledge of things by way of continuous comparison. He did more: he excluded the time element, thereby making possible the *simultaneous* appearance of things which in real life can only be seen in succession—for example, the front and the back, the inside and the outside of objects. Here he made contact with medieval painting, though without taking any backward step. Magritte's comparisons belong to the modern world, which is a troubled, distrustful world because of the repeated collapse of its convictions; it is unsure of itself because of increasing contradictions and the decline in the power of reason. Moreover, it is a world brought into turmoil by the share which the dream, the absurd, the irrational, and the insane now have in our lives. In contrast to the poetic thought of men like Hölderlin, Novalis, and Keats, who had a sublimated, nostalgic vision of the ruins of sub-

merged, nocturnal worlds or of ancient Greece, modern man looks out upon more recent ruins, those of a civilization bent on self-destruction. He has no time for nostalgic languishing.

Magritte paints strange ruins on the seashore, an open door, an absurd remnant of some collapsed edifice on the edge of the sea of man's powerful unconscious mind. He introduces fragments, balustrades, planks, bits of cornices. Are these propositions for a new society? Relics of an unknown age in the past? In any case they have a somber poetry.

When Coleridge sees poetry as "the direct and natural medium of the mind's activity"[27] and goes on to say that "it perceives hidden and a-logical connections, seeing and symbolizing one thing in terms of another to suggest new aspects of each," this could be taken as a perfect definition of what was to inspire Magritte more than a century later. The comparison can even be taken a little further. Those who knew Coleridge—including no less a figure than Thomas De Quincey—testify that he was "one of the rare class of minds which cannot contemplate any one

thing without becoming aware of its relation to everything else." Stephen Prickett qualifies this characteristic of Coleridge as "this myriad mindedness of Coleridge, this power to perceive a vast complex of simultaneous relationships."[28]

Magritte's mental activities belonged to the same class, although being a painter he had visible works in mind. Wordsworth, Coleridge's close friend, was also fond of altering images on the basis of resemblances. Thus Wordsworth had the image of a gigantic stone on the bare top of a mountain, so that no one could understand how such a stone could have gotten there; Wordsworth then completed the picture with a sea lion on a rock. Similarly, it occurred to Magritte to balance a huge lump of granite on the edge of an abyss high in the mountains (*The Glass Key*, 1959). It is typical of Magritte that, contrary to the ideas of Valéry and Poe, he should have spoken of the "coming about" of resemblances rather than the "discovery" of what already existed but had so far remained unknown. He had no qualms about speaking of "inspiration." The illumination occasioned a kind of panic in him, and the flash of inspiration must have been very powerful indeed for him to have referred to it as a birth. But he found it impossible to discuss. He was gripped by the mystery and stated that the moment of illumination lasted for only a very short time.[29] Furthermore, in a letter of May 9, 1967, shortly before his death, he wrote, "But the rare moments when I really have the sensation of mystery do not form part of the period of curiosity."[30]

A whole chapter could be devoted solely to the part played by doors in Magritte's work. They are often mere fragments around which the rest of the architecture has been destroyed and has disappeared. There are closed doors—but while painting them, Magritte kicked a hole in them to reveal a street behind or a view of the sea. There are open doors as well, though they stand, absurdly, in an open space. Or we may see a cupboard door that has just been opened to reveal the secrets of the interior. They all have one feature in common: they would be useless, with impaired functions in impaired, uncertain landscapes, were it not that they are all charged with some psychical activity: they reveal some aggressive event which has taken place beforehand. Moreover, they retain something which is of the essence of "shutting out" or "allowing access." Sometimes Magritte forced them open or opened them halfway to allow clouds to enter, but they are always doors which our human duality is accustomed to erecting on the frontier line between the visible and the invisible.

We are reminded here of Gérard de Nerval, who, in *Aurélia*, spoke of "going beyond the gates which separate us from the visible world" and, in the reverse direction, wrote, "I have not been able to go without trembling through those gates of ivory or horn which separate us from the invisible world."

BIOGRAPHICAL OUTLINE

1898 René-François-Ghislain Magritte is born on November 21 in Lessines, in the province of Hainaut in Belgium, the son of a merchant. (Of his two younger brothers, Raymond and Paul, the latter displayed a talent for poetry and music.)

1899 Family moves to Gilly, where a balloon lands on the roof of their house.

1910 Family moves to Châtelet, where life is apparently full of problems for Magritte's mother.

1912 Studies at the Lycée Athenée. Magritte's mother drowns herself in the river Sambre one night and is found with her nightdress covering her head.

1913 Magritte, his father, and his two brothers move to Charleroi, where, at a fair, Magritte meets Georgette Berger, his future wife. He attends the Athenée (high school) for three years, and afterwards takes lessons in drawing and painting.

1916–17 Registered at the Académie des Beaux-Arts in Brussels, where in 1918 his family goes to live.

1919 He moves among young members of the avantgarde: Pierre Bourgeois, poet and initiator of *7 Arts;* Victor Servranckx, later an abstract painter; and Pierre Flouquet, with whom he shares a studio for a while. However, they do not succeed in getting him to go along with them. He feels more at home among young writers who do not follow the lively Belgian Expressionist line but are attracted by Dada and the beginnings of Surrealism in Paris. One of Magritte's earliest kindred spirits is the poet and art dealer E. L. T. Mesens, internationally known for his Surrealist collages. It is he (and not Marcel Lecomte) who shows him illustrations of De Chirico's work. Later Magritte meets Marcel Lecomte, Camille Goemans, Paul Nougé; these are joined later by Louis Scutenaire, Paul Colinet, Marcel Mariën, and Achille Chavée. This group of young people, interacting with each other and sympathizing with Tristan Tzara and especially André Breton in Paris, formed the basis on which Belgium made her contribution to Surrealism between 1925 and 1930, with Magritte as an important figure among them.

1920 First exhibition in Brussels at the Galerie Le Centre d'Art.

1922 Magritte marries Georgette Berger. Earns his

43. Georgette and René Magritte married, sitting before a screen by Magritte which was later overpainted in black. Laeken, near Brussels. 1922

living by working as a designer for a wall-paper manufacturer and by drawing advertisements for fashion houses; some remarkable examples of this work still exist.

1925–26 The turning point in his artistic convictions becomes visible. He paints a small Surrealist picture of a hand and a small bird (in the Nellens collection at Knokke), dated 1925 and inspired by the work of Max Ernst. This heralds *The Lost Jockey* (usually dated 1926), the work which marks his break with Cubism and Futurism. He is put under contract by the Galerie Le Centaure in Brussels in 1926.

1927 His one-man exhibition at the Galerie is received unsympathetically. His former friend Pierre Flouquet says angrily in *7 Arts* (May 1, 1927) that Magritte has fallen into the hands of literary advisers and dealers. Magritte decides to move to Paris with Georgette, and settles in the early summer at Perreux-sur-Marne, where his studio is the living room.

1927–30 These years in Paris witness Magritte's full artistic development. During this time he plays an active part in the Surrealist circle.

In 1929 Dali invites Luis Buñuel; Camille Goemans; Paul Eluard, his wife Gala, and their daughter; and Magritte and his wife to spend a holiday in Cadaqués. This historic

44. Georgette and René Magritte in the Jardin des Plantes, Paris. 1928

meeting leads to lively artistic contacts among them and a lifelong friendship between Eluard and Magritte. Breton admits the following to the Surrealist circle in 1929: René Char, Buñuel, Dali, and Magritte; André Thirion says that this signifies a splendid reinforcement of the Surrealists' ranks.

In Paris, Magritte has important contacts with some of the occupants of the celebrated house in the rue du Château—including Yves Tanguy, Jacques Prévert, Malkine, Benjamin Péret, André Thirion—a center for discussions about eroticism, psychoanalysis, and communism (including Hegel, Marx, Freud). Thirion writes for the Belgian publication *Variétés* and is friendly with Louis Aragon, Man Ray, and such Belgian Surrealists as Goemans and Mesens. Nougé and Scutenaire visit occasionally, Nougé particularly being highly thought of by Breton. The Breton circle, which the Magrittes frequent, is stricter in its views and behavior than the rue du Château circle. There Magritte sees the interesting exotic collection and works by De Chirico, Ernst, Picabia, Duchamp, and Picasso. Georges Bataille is an influential guest. In the Café Cyrano in the Place Blanche, the Magrittes also often join the *réunions à l'apéritif,* over which Breton unofficially presides and where the novices are put forward, tested, and sentenced by Breton to admission to the circle or rejection. Magritte's relations with Miró are mutually cool. Magritte moves particularly among the habitués of the rue Fontaine, Breton's headquarters, and those of the Café Cyrano.

Camille Goemans exhibits Magritte's work in his Surrealist Gallery at 49, rue de Seine, Paris, until his bankruptcy. When Le Centaure in Brussels is also obliged to terminate its regular financial aid, Magritte finds himself without the means to stay on in Paris.

1930 The Magrittes return to Brussels, taking up residence at 135, rue Esseghem, Jette-Brussels. They live on restricted means, among a select circle of friends; their life is devoid of any startling happenings and, in the eyes of outside observers, is that of the *bon bourgeois* of Brussels.

1934 The publication of *Invention surréaliste (Documents 34),* in which Breton, Eluard, Char, and others voice their deep disturbance at the

45. Paul Nougé and René and Georgette Magritte on bicycles at the Belgian coast. Ostend. 1933–34

gritte delivers a lecture of great documentary value for an understanding of his creative process. In 1936 the art dealer Julien Levy, author of some sensitive essays, had given the first one-man exhibition of Magritte's work in New York, and now another exhibition follows. The background to these exhibitions is provided in an essay on Surrealism by Levy (Julien Levy, *Surrealism,* New York: The Black Sun Press, 1936).

1938 The London Gallery opens with an exhibition of Magritte, the first in London, consisting of 46 works (including objects). Between April 1, 1938, and June 1940, Mesens publishes *The London Bulletin* in twenty issues of documentary significance. Herbert Read writes of the importance of the "poetic principle" in Magritte's work.

1940 Magritte is among those Belgians who flee the

powerful rise of Fascism and protest violently against it. Mesens, Magritte, Nougé, Scutenaire, and Souris add their views in a sort of manifesto called *L'Action immédiate.* It is an earnest searching of their consciences regarding the possibilities and the limitations of their revolutionary campaign seen in relation to that of the Communist Party. They have great faith in the mental dynamite of their works, whether painted, written, or spoken.

1937 Magritte stays in London for three weeks, in the Wimpole Street home of Edward James, for whom he makes gouaches and paintings, some new, some variants of themes James selects from photographs of Magritte's works. In this year (and also in 1938 and 1939), Ma-

46. Magritte painting in the house of Edward James, London. 1937. Left: ON THE THRESHOLD OF LIBERTY. Right: THE RED MODEL

47. Magritte before the second, vertical version of ON THE THRESHOLD OF LIBERTY

48. Georgette and René Magritte with their dog during the war

country, apprehensive of German occupation. Georgette remains behind. Magritte spends three months of exile in Carcassone, is utterly bored with life, but produces a remarkable gouache, *The Wedding Breakfast* (fig. 28).

1943–46 Back in Brussels, Magritte gives full rein to an apparently suppressed urge to paint like Renoir—which contrasts sharply with the inventions he has presented so far in strictly formulated, exact, and smooth paintings.

1945 After the Liberation, Magritte's nonconformist social convictions become strong once again, but an attempt to cooperate with the Communist Party ends in disillusion, and he turns away from it.

1948 Magritte's *époque vache,* as he himself called it, is a brief burlesque interlude in the comic manner, lasting two and a half to three months, when Magritte tries to paint in the French Fauve style. Exhibited in Paris, the work of this period has a poor reception. The exhibition was suggested and introduced by Louis Scutenaire, who defended the work. Although this exuberant production hardly fits with the image Magritte had established of himself, it is possible that it will find more defenders—

like Scutenaire and Roberts-Jones—later on.

1953 Magritte completes a commission (of 1951) from Gustave Nellens, director of the Municipal Casino at Knokke-Le Zoute, to decorate the gaming room with murals, entitled *The Enchanted Domain.* Magritte's international fame grows, and his work is exhibited in Rome, London, New York, and Paris.

1954 After twenty-one years, Brussels presents an important retrospective exhibition of Magritte's work in the Palais des Beaux-Arts; in consultation with Magritte, it is organized by Robert Giron and advised by Mesens. (Exhibitions follow in 1959, 1960, and 1962 at Ixelles, Liège, and Knokke respectively.)

1956 Magritte is awarded the Guggenheim Prize for Belgium.

1957 Magritte moves to 97, rue des Mimosas, Brussels-Schaerbeek, where he remains until his death. The Palais des Beaux-Arts in Charleroi commissions a mural, *The Ignorant Fairy (La Fée ignorante).*

1960–67 International recognition, late in coming, is now at its height.

The Museum for Contemporary Art in Dallas, Texas, in 1960 organizes the first retrospective exhibition in the United States, consisting of 82 works, which then goes to Houston.

The Palais des Congrès, Brussels, in 1961 commissions a mural, *The Mysterious Barricades (Les Barricades mystérieuses).*

The Walker Art Center, Minneapolis, in 1962 presents a survey organized by the Ministry of National Education and Culture of Belgium and the Belgian Art Foundation in the United States, consisting of 92 works.

In 1964, in Houston, the Art Department of the University of St. Thomas organizes an exhibition of 100 works.

In 1965 The Museum of Modern Art in New York organizes an exhibition of 82 works. Magritte, accompanied by his wife, by Louise de Vilmorin, the French writer, and by Margaret Krebs, is received with full honors. His friend and a collector of his works, Harry Torczyner, takes him to visit Edgar Allan Poe's house. He also visits the De Menils, fervent collectors of his work, in Houston, Texas.

In 1967 the Museum Boymans–van Beuningen

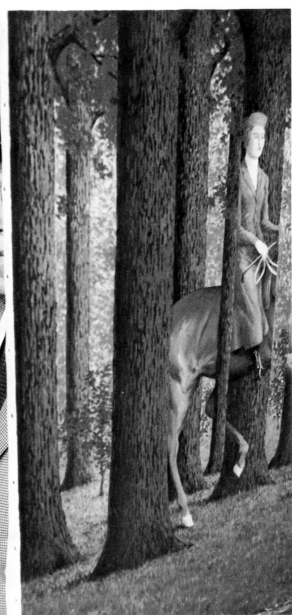

49. Magritte behind
SIGNATURE IN BLANK. 1965

50. Magritte (at right),
Paul Delvaux, and E. L. T.
Mesens (standing) dining
after a vernissage at
the Hotel La Réserve,
Knokke-Le Zoute

in Rotterdam organizes a retrospective exhibition of 105 works.

Magritte dies, unexpectedly, in Brussels on August 15, 1967.

1969–71 After Magritte's death four large retrospective exhibitions are organized: at the Tate Gallery, London; at the Kestner Gesellschaft in Hanover; in the Kunsthaus in Zurich (all in 1969); and in Japan (Tokyo and Kyoto) in 1971.

1972 The English dramatist Tom Stoppard, author of *Rosencrantz and Guildenstern Are Dead,* writes a one-act comedy entitled *After Magritte,* performed at Theater Four, New York, in April 1972.

1973–78 Important exhibitions in London (1973); Houston (1976); Paris and Brussels (1978).

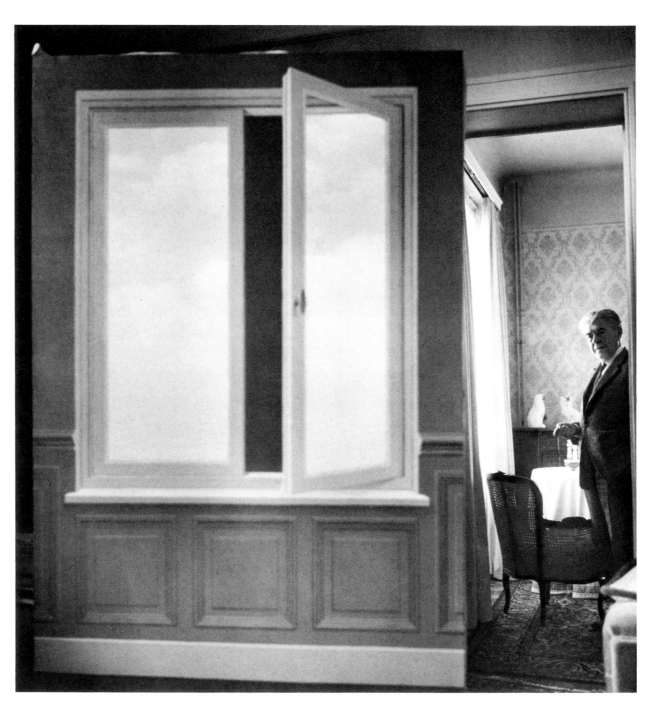

51. Magritte with THE FIELD GLASS (*La Lunette d'approche*) in his room at 97, rue des Mimosas, Brussels. 1963

COLORPLATES

Painted 1926

THE LOST JOCKEY
(LE JOCKEY PERDU)

Collage and gouache on paper, 15½ x 23½"

Collection Harry Torczyner, New York City

Although Magritte would change the title and the setting, he repeated the theme of the jockey on a racehorse again and again, over a span of almost forty years. It first appeared during his years of imaginative investigation in the mid-1920s when he discovered a different function for painting from that developed by the Futurists, Cubists, and abstract artists.

One of the tasks Magritte set himself was the resurrection to new and unusual life of the ordinary things of our existence, which become stale due to the careless way we perceive them. Instead of accepting conventional things as they were, Magritte began a challenging game with them to resuscitate not only their stranger aspects but those which cannot be named; to this end, he devised new functions for them.[31] For instance, he transformed ordinarily boring table legs made of turned wood into "chessmen" in a copse. As his source of inspiration for these figures Magritte himself mentioned only the table legs. But the term "bilboquet," which was later applied to these forms, I can see only as a reference (not meant to be taken literally) to something that falls over but rights itself again. It also indicates an old-fashioned toy, used in the cup-and-ball game—a small wooden ball attached to a cup by a string— metaphorically (see Littré, *Dictionnaire de la langue française*) a thing which always lands on its feet. In addition, the term is used for a person lacking stability. Always sensitive to words and language, Magritte created a form of his own to express this complex of ideas. This kind of innovation marked the beginning of Magritte's fabrication of his own alphabet and grammatical system.

The Lost Jockey was probably begun with hesitation. One version had been lost, and then, in Paris in 1972, a *Lost Jockey* (Collection Robert Michel) turned up at the exhibition *Peintres de l'imaginaire,* showing a very clumsy jockey set among bilboquets from which branches are growing. The canvas was in bad condition—with cracks in the paint, such as have rarely occurred in later Magritte works—and had the appearance of being an awkward initial attempt. It was soon replaced by Magritte's first masterfully completed version of it, the splendid collage-gouache illustrated here.

This version is important, since it introduces theatrical elements: the curtains and the transposed winter woods with bilboquets cut from sheets of burlesque music (bearing such texts as *"Sprechen Sie Deutsch, mein Herr?"*). The entire middle section has been kept very bright, with a faint tracing of lines across the floor, the color changing as it moves upward to shades of blue. The bars of music contribute rhythmical transparency to the picture, in which the jockey theme becomes lost as though in some enchanted domain.

COLORPLATE 2

Painted 1926

THE BIRTH OF THE IDOL
(LA NAISSANCE DE L'IDOLE)

Oil on canvas, 47¼ x 31½"

Private collection, Brussels

Magritte repeatedly depicted the jockey and especially the bilboquet (see colorplate 1), and often added the form of the mannequin or dummy—as in *The Birth of the Idol*—which had been first used in painting by Giorgio de Chirico. *The Birth of the Idol* is, in fact, a striking example of the impact De Chirico still had on painters more than ten years after his innovations.

In the storm above a tumultuous sea depicted here, Magritte displays an expressive power which hardly ever occurs later. Already there are such elements as the blind staircase and doors with openings in them, while the idol rises in the oppressive scene like an unattractive bilboquet-dummy from the cut-out silhouette of a human being.

The Lost Jockey and *The Birth of the Idol* indicate well how fertile and inventive Magritte's imagination was in 1926. Subject to changing moods and emotional stress now that he had found his way as though by revelation after much hard searching, Magritte also experienced that nervous unrest and excitement typical of the enthusiasm and industry of a young talent. Something of this can be traced in these two works of 1926, probably against his wish. It does not occur again after 1929.

Painted 1926

POPULAR PANORAMA
(PANORAMA POPULAIRE)

Oil on canvas, 47¼ x 31½"

Collection Mme Jean Krebs, Brussels

The year 1926, when Magritte was twenty-eight, marked a definite turning point in his work, as has been stated in regard to *The Birth of the Idol* (colorplate 2), and the landscape, as he saw it in *Popular Panorama,* was of fundamental importance to his further evolution. Besides having been in E. L. T. Mesens's possession, this canvas was for a long time owned by Paul Gustáaf van Hecke, Magritte's first art dealer, who took an interest in him and ran the Galerie Le Centaure with André de Ridder.

No support at all can be found in Cubism or Futurism for Magritte's unique conception of space here—except that Cubism had opened the way for other attitudes toward space besides the fixed one of Renaissance perspective. Magritte presents three strata here which form a unit yet are autonomous in regard to perspective. The two surfaces, with sawed, curvilinear edges, are simultaneously beach and woodland scenes, but they also suggest the materiality of wood, for example; thus the effect is that of a kind of magical box where three aspects of landscape have been confined but which has been sawed into so they can be visible. Through the superimposition of three elements in the painting—town, woods, sea—a simultaneity has been created to which shortly afterward, in 1928–30, Magritte gave still greater emphasis in strangely framed fragments of these and other motifs. The tonal color, which has been applied very thinly, is a dull greenish gray, creating the rather oppressive and somber atmosphere typical of this period.

Magritte's vision of trees, which fascinated him his whole life, is very important. What interested him most here are the trunks—squat, warped, powerful, lacking the tranquillity they later acquired in his work. They shoot straight out of the surface, without any roots; years later, too, Magritte ignored the fact that trees have roots. Does this phenomenon perhaps have a connection with the fact that Magritte lived in houses but never took root in them, never considered where he lived as a matter of importance and could move from place to place with ease?

Compared with the landscape forms in *Landscape* of 1926 (fig. 4), which defy description and are recognizable only through associations, *Popular Panorama* is a more concrete view of landscape more immediately derived from the real world; yet, because of its layered space, it is no less dynamic in imaginative power.

Painted 1926

UNTITLED
(SANS TITRE)

Collage and gouache, 30¼ x 23½"

Collection Mme J. Vanparys-Maryssael, Brussels

The use of collage is a legacy from the early Cubism of Picasso and Braque, and was part of the revolutionary change in the materials and techniques employed in painting, which until then had been limited almost exclusively to oils. Jean Arp and Kurt Schwitters broadened the range of possibilities. Between 1925 and 1930 Magritte made limited use of collage by cutting up musical scores to introduce ambiguous elements into his works. Because of the shape of these elements, they remind one both of parts of musical instruments (such as the neck of a violin or cello) and of burlesque figures resembling marionettes (the creatures of modern fable: bilboquets and mannequins).

The curl at the end of the neck of the violin or cello appears as early as 1916 in works by De Chirico—for example, in his painting *The Jewish Angel* (Penrose Collection, London; fig. 11). De Chirico also employed the rhythmical black dots which Magritte too used now and then in the 1926–30 period. Magritte made something highly original of this by the imaginative use of musical notation; the evocation of music escapes no one—it causes everything to lose its heaviness.

In the gouache of this type and period, Magritte evolved a fantasy which is full of transitions from one state of being to another, until he arrived at the unrecognizable. It was a mental activity which was metaphorical, as regards the form, material, structure, and function of things. (See also page 66.)

In these works Magritte was on his way to a world that is artificial, where things lead an abstract existence. Yet he sought to preserve a relationship with visible reality. For this reason his work is not so hermetic as that of Yves Tanguy, for example, and Magritte did not create a territory that is so inaccessible as his. Magritte's territory lies halfway between the recognizable reality of the things among which, and with which, we live and a metamorphosed world which has grown out of the activities of his inner being.

Painted 1926

THE WORLD'S BLOOD
(LE SANG DU MONDE)

Oil on canvas, 28¾ x 39½"

Private collection, Brussels

From 1925 on Magritte took two paths, one of which he was still following about 1930. *The World's Blood* and *Landscape* (fig. 4) belong to a group which he abandoned after 1930 and which is clearly distinct from the works based on recognizable figures, belonging to a world of people and objects brought into strange relationships with one another and placed in unexpected settings, as exemplified by *The Lost Jockey* (colorplate 1), a theme which Magritte took up again and again.

The other direction, which emerged shortly after the motif of *The Lost Jockey,* consisted of invented organisms, vegetation, and forms only indirectly and ambiguously related to reality. Only through associations can one approach these oppressive landscapes; visually tangible and clear, they are peopled by forms that are intertwined in the Baroque manner.

The culmination of these works is *The Taste of the Invisible* of 1928 (fig. 36). The title itself confirms that the path indicated by this work is not the same as that which later was founded so firmly on "the visible."

The World's Blood shows organisms resembling legs and arms which lack their extremities and have been skinned, like those in pictures of anatomical lessons. The round forms which they partly cover are even more difficult to approach. The art historian could venture a reference to Arp's forms in his Dada period, or one may be reminded of Yves Tanguy. Magritte, who made these paintings shortly before or during his years in Paris, from 1927 to 1930, saw many things in André Breton's circle there, but this fact does not, I think, lead us in the right direction. The forms immediately behind the so-called flayed legs, for instance, may seem like certain phases in rock formation, with signs of erosion. Antoni Gaudí, the Spanish Art Nouveau architect, fashioned similar "growths," and Dali was always fascinated by them on the shore of Cadaquès, near his birthplace. Magritte gives them artificial colors here— bloodred and off-white.

I would also refer to some short prose pieces which Magritte wrote during these years, with semirealist, semidreamlike figures set in landscapes. These pieces have a literary quality and a Surrealist freedom which could have led to a literary career, but among the Surrealist artists only Dali persevered as a writer, with remarkable erudition and wit.

In *The World's Blood* one can discern the demon in Magritte's imagination, the obsession with a dark fertility urge which has a perverse side to it; it was a remnant of Expressionism, from which he freed himself about 1930. Then came the clarification, the mysterious clarity, of which he was a master as early as 1926. Even though dark and somber tones are dominant in numerous works before 1930, relatively bright works appear at times from 1926 on —for example, *The Secret Player.*

COLORPLATE 6

Painted 1925–27

THE OASIS
(L'OASIS)

Oil on canvas, 29½ x 25½"

Collection Mme J. Vanparys-Maryssael, Brussels

One or more years before *The Cultivation of Ideas* of 1928 (colorplate 13), a work in which trees without roots are seen on a strange plain of wood, Magritte painted *The Oasis,* a simpler work with a title that is literal and presents no problem at all. Scutenaire dates this work to 1925.

The small table on which the trees are standing (unreal trees, consequently) is painted in Chinese perspective, reversed and not systematized as in European Renaissance perspective. The clouds appear partly in front of and partly behind the crowns of the trees, while the distance between the clouds and the ground is too small to be realistic. Thus Magritte has altered spatial proportions here and shown that perspective is relative. In other words, he has tried to free the natural world from the rules and customs to which it is subjected by our conception of it. Through his presentation our perception becomes intensified, while our experience of space becomes a more intimate one. There is an infinite silence in this painting. In the clouds (but not on them) is a bright light, and the blue of the sky on the horizon changes color until it approaches the deep midnight blue I have seen elsewhere only in fourteenth- and fifteenth-century Italian painting. For instance, Mantegna in his *St. Sebastian* painted clouds of this kind, of intense coldness, in a powerful, penetrating blue. In addition, the concept of space here, which has not been subjected to an academic formula, may make us think of Piero della Francesca and Uccello. The attractiveness of *The Oasis* is the absence of all stereotype effects or mere dexterity; the style of painting is laborious, austere, direct. A very early dating—1925, before *The Lost Jockey* (colorplate 1)—seems feasible.

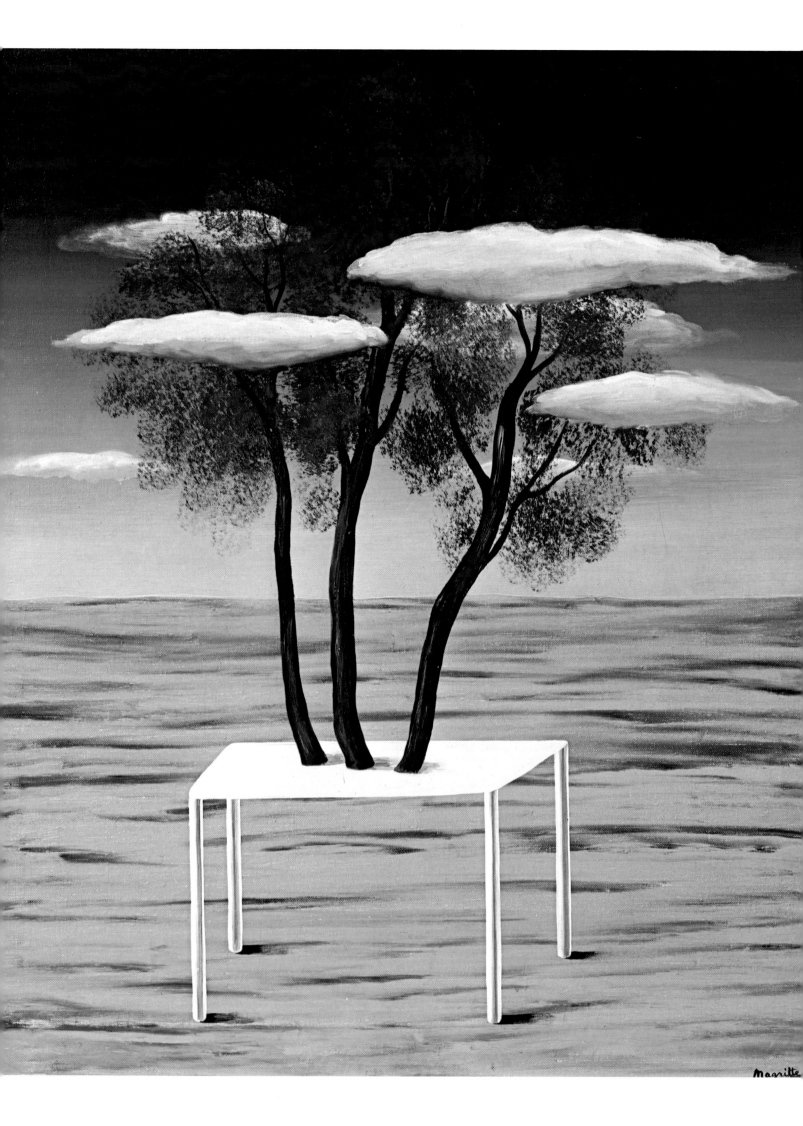

Painted 1927

MAN WITH NEWSPAPER
(L'HOMME AU JOURNAL)

Oil on canvas, 45½ x 32"

Tate Gallery, London

In 1936 Paul Nougé commented on Magritte's works under the collective title "René Magritte ou la révélation objective" (René Magritte, or Objective Revelation) in his *Histoire de ne pas rire*. Irène Hamoir saw his work in an analogous way, writing, "His pictorial phrases are legible, neat, and brief."

The *Man with Newspaper* belongs, with *The Sleepwalker* (1927) and *The Voice of Silence* (1928), to that small group of works which assemble the objects that make up the petty-bourgeois household interior; they present the most banal of data, objectively, without words, and very legibly.

In *The Sleepwalker* Magritte was already engaging in a game with the interior and the exterior by placing a lighted lamppost in the small room, which contains the same little stools as the room where the man is reading his newspaper. The presence of the lamppost transforms the ordinary world, and the new world becomes frightening and strange.

There is nothing disturbing, however, about the surroundings of the man reading his newspaper. The stove (compare it with the cannon in *On the Threshold of Liberty,* colorplate 15) appears to be of the catalogue type once in fashion. The decoration on the wall is the most absurd and the most ordinary imaginable. The window with the curtains, the small bouquet of flowers on the windowsill, and even the view are exactly of the kind the petty bourgeois selects to create the required atmosphere in his home. Even the man himself is the sort one sees in advertisements and on postcards. Magritte found the scene in an 1890s medical book, *La Nouvelle Médication Naturelle* by F. E. Bilz.

But what does Magritte do with this material? He divides the canvas into four rectangles and paints the same little room four times, showing the man reading his newspaper in only one of these scenes. By being removed from the picture, the man becomes invisible. If Magritte had eliminated him only once, the effect would not have been disturbing, but he does it three times. This repetition alone is sufficient—and necessary—to show that despite the man's having disappeared, nothing essential has changed. His visibility had no meaning; his existence was empty.

Nevertheless, it is mysterious that the man's becoming invisible does have some effect; the man reading his newspaper did apparently represent something human. Yet the nonexistence of the existent newspaper reader evokes the idea of living in a rut. Magritte has rendered the awfulness of the banal and the vacuous in visible terms.

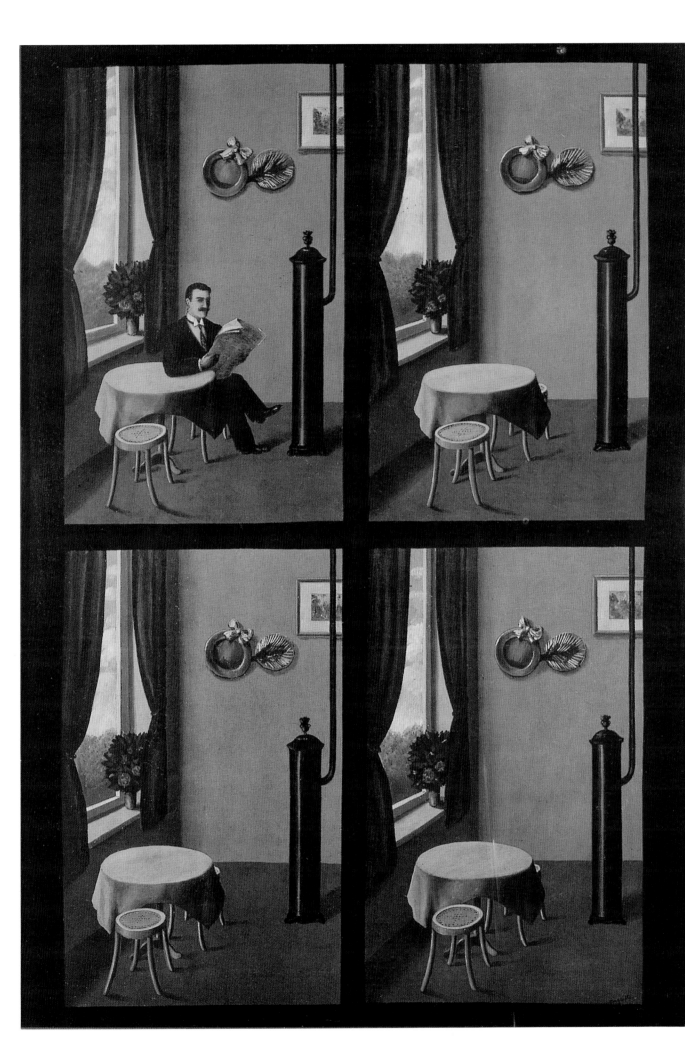

Painted about 1928

THE SIX ELEMENTS

Oil on canvas, 28⅞ x 39¼"

Philadelphia Museum of Art. Louise and Walter Arensberg Collection

During the 1928–30 period particularly, Magritte painted forms which were actually denaturalized picture frames, sometimes containing nothing at all, sometimes containing words, sometimes with a plank showing the grain in the wood, and sometimes with a collection of unconnected elements. The last-mentioned type culminated in the painting *On the Threshold of Liberty* of 1929 (colorplate 15), which is composed of eight parts surrounding a cannon. *The Six Elements* preceded this painting and shows fire, clouds, woods, a house, the bells on a horse's harness, and a female torso. In the work as a whole there is a poetic eroticism.

The frame is baroque in its fancifulness and irregularity, lending tension to the six fragments. From the purely plastic viewpoint the work is masterly in its composition. The breasts, the luxuriant woods, the infernal fire, and the clouds in the blue sky all belong to the realm of nature. The bells evoke sound, and the fragment of a facade, flanking the dreamy sky, keeps the composition as a whole close to the earth. A house always meant many things to Magritte; it was not merely a shelter, not merely a framework, but the center from which he experienced the dialect between the "inside" and the "outside," the finite and the infinite.

In 1928 Magritte also painted another variant of the "six elements" (now entitled *The Empty Mask*, Collection Raymond J. Braun family, New York City). In this version the composition is different, and the woman's torso has been replaced by a painted cutout like that in *The Comic Spirit*.

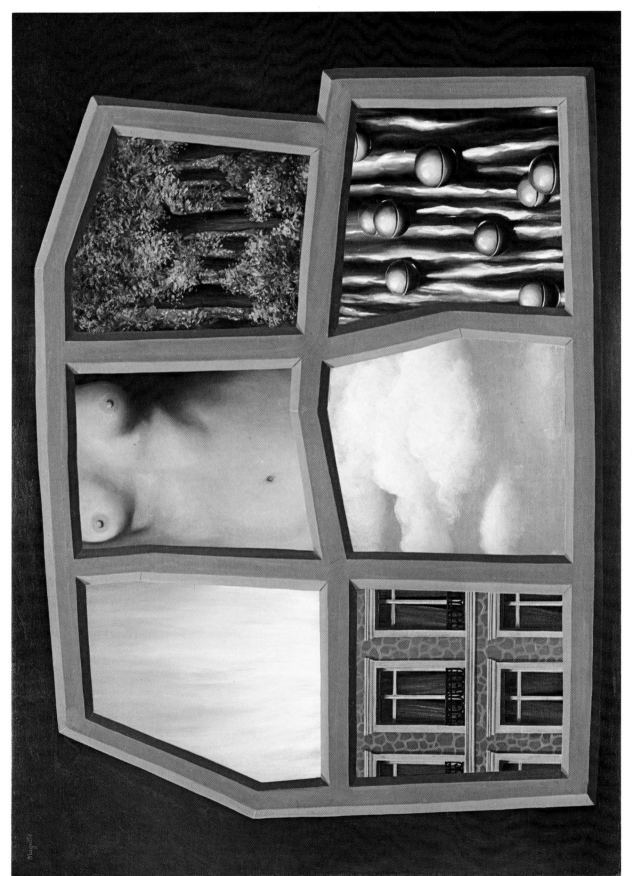

Painted 1928

THE FALSE MIRROR
(LE FAUX MIROIR)

Oil on canvas, 21¼ x 31⅞"

The Museum of Modern Art, New York City

Man Ray has told me that he and Magritte used to meet at times during Magritte's years in Paris, and that a slight link continued to exist between them afterward; if Magritte was in Paris, he would look up Man Ray, and Man Ray would sometimes visit Magritte in Brussels. It was during his Paris years that Magritte saw at Man Ray's studio a large photograph of an eye Man Ray had made. Magritte was so fascinated by it that he wanted to have it for himself, and later on he gave Man Ray something in exchange—a painting in which the eye was the motif. According to Man Ray, this work was eventually purchased by Alfred H. Barr, Jr., for The Museum of Modern Art in New York.

The False Mirror is a deliberate reduction of the natural function of an eye. The remarkable thing is that, like the Byzantine eye, it does not actually look at us, the viewers of the work. This is because Magritte avoids here the eye's active function—looking—by showing only its reflective function—the reflection in the cornea of the sky and clouds. The reflection in the mirror is passive, dead, but the reflection in the eye penetrates the interior and it is there, inside the eye, that the image comes into being. Magritte had a deep response to a one-line poem by Paul Eluard: *"Dans les yeux les plus sombres s'enferment les plus claires"* (In the darkest eyes the brightest eyes have secluded themselves).[32] Magritte was never to forget Eluard's moving line of verse.

Thus Magritte avoids here the Surrealists' sexual play with the motif of the eye. (His friend Eluard, however, owned a curious collection of early nineteenth-century picture postcards, kitsch products, which were published in an issue of *Minotaure;* in these the eye with scabrous little figures coiled up inside it was shown frequently.)

In 1932 Magritte painted for Georgette, his wife, an eye with an eyebrow and a plait of hair on wood (fig. 38)—a material he rarely used. It is entirely unrelated to his conception of 1928, for it is now an eye which looks at things; it is human, without the dialectic of the reflection.

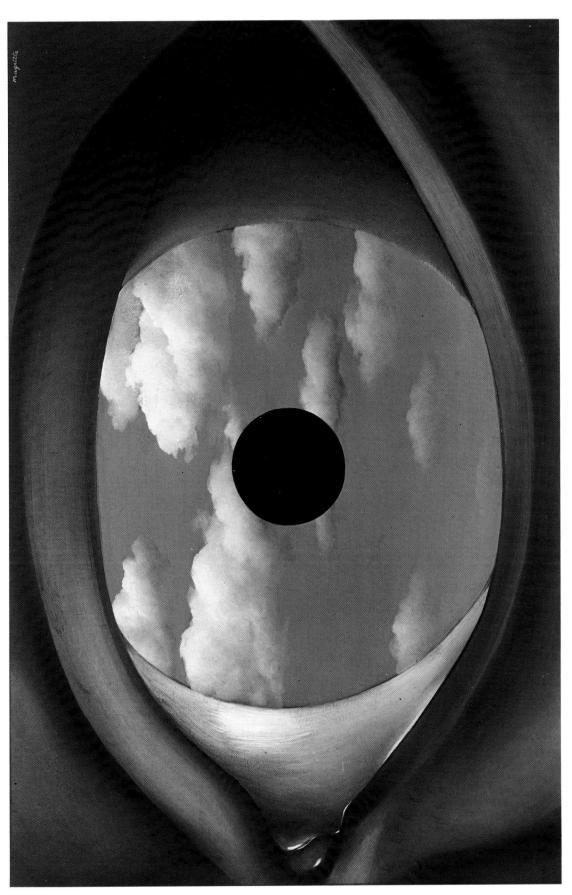

Bottom

Painted 1928

DISCOVERY
(DECOUVERTE)

Oil on canvas, 25½ x 19¾"

Collection Louis Scutenaire, Brussels

If Louis Scutenaire's dating of 1928 is correct, this work was executed in Paris, when Magritte was living among militant Surrealists such as Breton, Aragon, Tanguy, Dali, and Goemans.

The title of the painting is clear: that which exists but had remained concealed and unknown is revealed. The apparent simplicity of various paintings belonging to this period is suddenly disturbed by the unexpected alteration here in the material of the skin of the naked figure. The grain of wood, which was an obsession with Magritte, appears here like a tattoo on the skin of the naked woman, making it even more sensual and adding both a somber and voluptuous quality to the painting. Moreover, the unusual idea of the grained wood appearing in the skin, like the beginning of some imminent transformation, removes this nude to the realm of the semidream. To this I would hesitantly add—being aware of Magritte's rejections of psychoanalytical interpretation—that Freud saw a connection between wood and the idea of the woman, the mother. He referred to the name "Madeira," the wooded island, since it means "wood" and is derived from the words *mater* (mother) and *materia* (material).

Magritte considered a picture like this one to represent an evolution of the concept of combined objects: things *gradually* becoming something else.

Recollections of the flame patterns in wood and of the charms of woman's naked flesh have converged in Magritte's imagination, enriching his conceptual powers to an unusual degree.

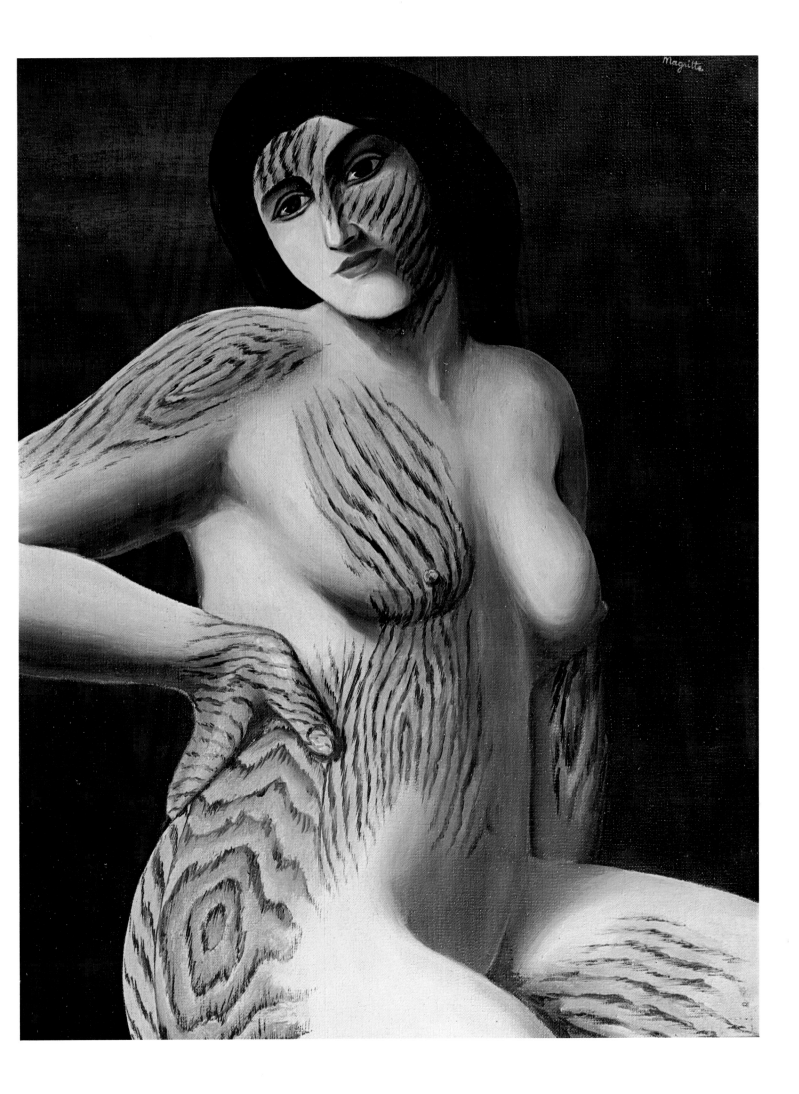

COLORPLATE 11

Painted 1928

THE HUNTSMEN ON THE EDGE OF NIGHT (LES CHASSEURS AU BORD DE LA NUIT)

Oil on canvas, 31½ x 45⅝"

Private collection, New York City

In Magritte's Paris years somber colors predominated—bronze, olive green, ochers, dark blue, brown; the wall here is blue-gray and luminous. The bodies of the huntsmen have clear, simple contours, and their hands are rough and broad, almost animalistic, like those of the figures in *The Titanic Days* (colorplate 14).

In 1928 the author and art dealer Camille Goemans (who had opened the first Surrealist art gallery in Paris, at 49, rue de la Seine) published a story in *Distances* entitled "Les Débuts d'un voyage" which is about huntsmen who set out on a nocturnal excursion through a wooded domain and is full of dark moods of oppressive anxiety, imminent danger, and exhaustion.

Although Magritte's painting is not an illustration of the story, the two resemble each other, for Magritte's men are depicted with gestures of despair, groping in panic at a wall to find a way out. Although claustrophobia is not predominant in Magritte's work, it does occur occasionally, as in this example. Moreover, like *The Titanic Days,* this painting has an element of drama and expressive gesture, which, however, soon dwindled and did not occur again after 1930.

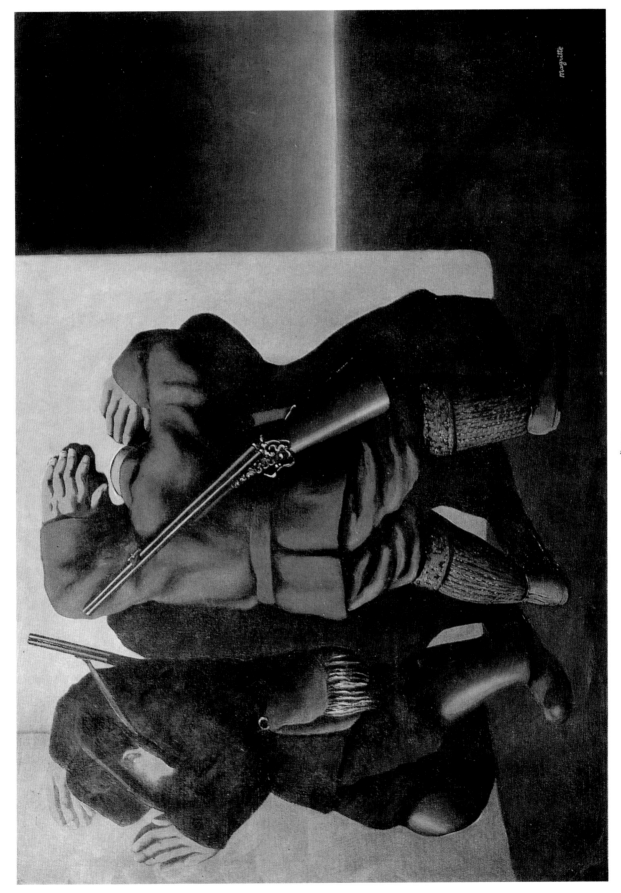

Painted 1928

THE REGALIA OF THE STORM
(LA PARURE DE L'ORAGE)

Oil on canvas, 31½ x 46⅛"

Collection Baron J. B. Urvater, Paris

In 1928 Magritte's themes and titles often revealed a dynamic, violent, and somber emotion, as in *The Titanic Days* (colorplate 14), *The Huntsmen on the Edge of Night* (colorplate 11), and *Nocturne* (fig. 6).

The Regalia of the Storm (the translation of the title is by David Sylvester) contains the same boiling, nocturnal sea we encounter in *The Difficult Crossing* and *The Birth of the Idol* (colorplate 2), viewed through fragments of an architecture that resembles stage scenery. This work is most like a theatrical scene and least like De Chirico. It includes cutouts, which, in *The Comic Spirit* of 1927, are *painted* cutouts, but the painted, cut-out fragments of trees and leaves are of the same order: flat phantoms, yet also figures in space. *The Regalia of the Storm* matches Max Ernst's conception—it is, in spirit, a collage-*découpage*. The six personages appear firm; thin and transparent as they are, they nonetheless cast shadows, and their ghostly, burlesque presence, between serious drama and comedy, is like the fine foam of the waves which blows across the beach in fanciful nameless forms. *The Regalia of the Storm* marks a peak among the disturbing landscapes of this period, in which the shock of contrasting elements is overlaid by the dark tones of a solemn melody sung by deep bass voices.

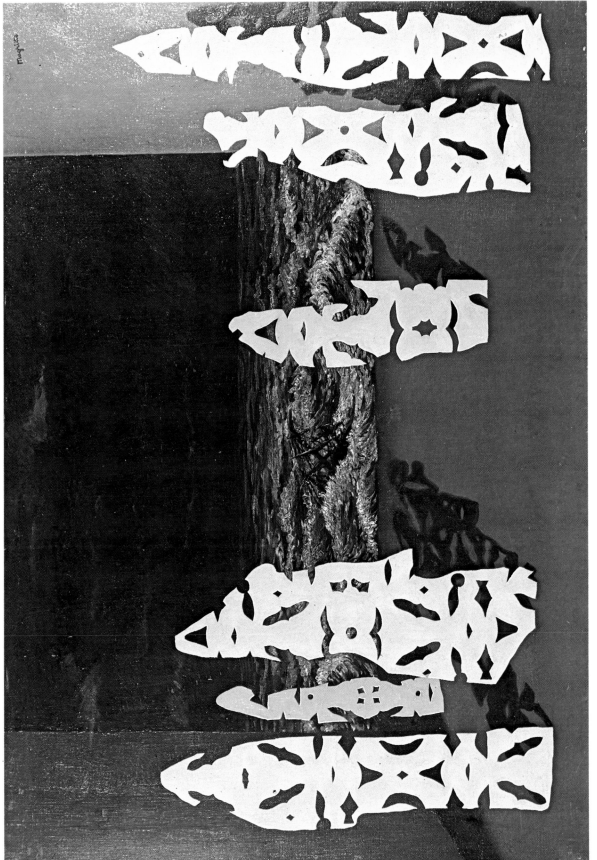

THE CULTIVATION OF IDEAS
(LA CULTURE DES IDEES)

Oil on canvas, 19¾ x 25½"

Private collection, Brussels

In this poetic painting, which is an artificial landscape, two trees form a single crown of leaves. As a result, the two trunks, with short shadows falling before them, seem like the legs of a man walking into the landscape. Nature advances too, even coming up through the floor, which consists of a cloudlike foreground with outlined forms, changing color only higher up to become wood with a distinct grain.

Even without the title, the painting has the strange poetic enchantment of the atmosphere a person senses just after waking up, when he is still only half-conscious, still hypnotized by some dream face that is about to elude him. This exceptional imaginative power in Magritte, creating shapes and colors difficult to define (except for the trees), no longer occurs in so lyrical and poetic a manner after 1930.

One can definitely trace a chronology and change of style in Magritte's work, even though it was not the aesthetic problem of style but an intellectual poetic vision, the evolution of a technique of creating resemblances, which occupied his mind. For instance, later repetitions of much earlier works are often recognizable by a more meticulous, calmer, and more relaxed finish and by details which bring about slight changes of atmosphere.

Bottom

COLORPLATE 14

Painted 1928

THE TITANIC DAYS
(LES JOURS GIGANTESQUES)

Oil on canvas, 45⅝ x 31⅞″

Private collection, Brussels

Here, against the same kind of somber blue, bluish green, or umber background which Magritte used in 1928 (as in *Discovery* or *The Huntsmen on the Edge of Night,* colorplates 10 and 11) to set off his figures in a hard light reminiscent of Caravaggio, he has painted a spectral silhouette of a strange rape.

He has deformed the naked lower part of the woman's body so that it almost seems she is suffering from elephantiasis. Her gesture is defensive, cramped, anxious. Especially unusual is the combination of the silhouette of the dark man, the woman's outline, and her shadow, which includes even the man's legs and feet. In proportion to the man's head (the face is forced away and the ear is seen in foreshortening), his hands are colossal.

The contamination of the two bodies, the confusion of the two pairs of hands, the violent effect created by the hard shadow—which is simultaneously a volume, absorbed into the heavy forms of the nude woman—give the painting a fierce and sensual yet cold animation that Magritte never again equaled.

After this his female nudes either expressed a sublimated contemplation or showed a perverse alteration of the sexual organs (as in the drawing *The Rape*). It is interesting to read Surrealist Belgian writing by Paul Nougé and others of the 1926–30 period (such as *La Chambre au miroir* and *Ebauche du corps humain*[33]) to become aware of the atmosphere of erotic fantasy, sometimes accompanied by typographical experimentation, in which also Magritte worked.

74

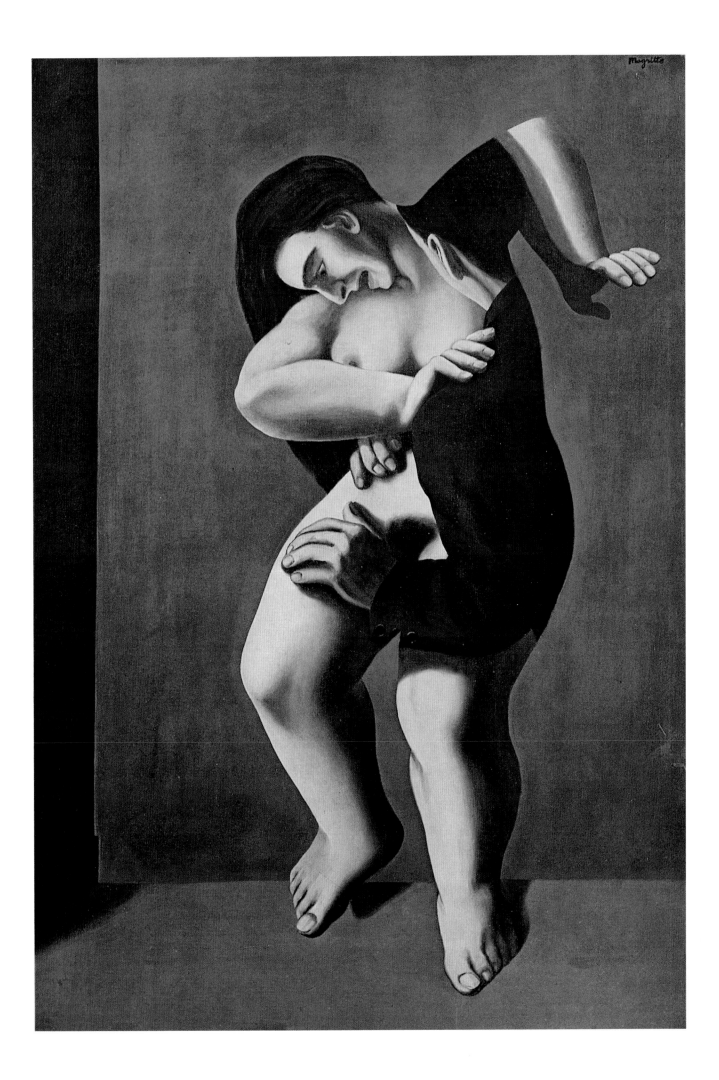

Painted 1929

ON THE THRESHOLD OF LIBERTY
(AU SEUIL DE LA LIBERTE)

Oil on canvas, 45 x 51¾"

Museum Boymans–van Beuningen, Rotterdam

The paintings *The Six Elements* (colorplate 8) and *The Empty Mask* of 1928 are flat conceptions, consisting of compartments presented frontally, whereas *On the Threshold of Liberty* of the following year has become a three-dimensional scene. Magritte repeated the motif in a vertical version at Edward James's request during a visit to his home in London (see fig. 47).

The 1929 canvas differs from the earlier ones in another respect besides its theatrical treatment of space: Magritte has added a cannon aimed at the woman's torso. Compared with De Chirico's cannon in *The Conquest of the Philosopher* (1914), which is an unstressed component of the painting, Magritte's cannon is an important object which exists in its own right.

It is interesting that this was no toy cannon; a military expert has identified it as a French 15-centimeter howitzer of the 1914–18 type, manufactured by Schneider-Canet, operating on the De Bauge system. If this is correct, it supports the view that Magritte did not work symbolically or fantastically but found the things of life—which he absorbed with great facility—sufficient to stimulate his imagination and ideas.

For the rest, the meaning of the work lies in the setting, composed of a number of selected items from nature and man's daily life, and in the spatial play. The eroticism of the woods and the nude is obvious, and the bare wood with its evident grain can also be associated with the erotic. The banal facade of the house, which is closed up, is juxtaposed with an image of the outdoor world, open and unrestricted, with splendid white clouds floating in a blue that is wholly characteristic of Magritte. The harness bells, on a sheet of corrugated lead, conjure up the sound of trotting horses. The fierce fire and the flat, paper cut-out pattern form the palest and the least emphasized side of the scene.

Magritte provided a sketch of *On the Threshold of Liberty* in a letter to Paul Nougé,[34] with an explanation of the choice of the sky, the woman, and the landscape. The picture amounts, in fact, to a regrouping of isolated elements of life—the reorganization of a world of which both the Surrealists and Magritte had a poor opinion: "This world in disorder and full of contradictions which is ours," as he used to say, still has aspects, such as psychical experiences, which have been left unexploited and undeveloped. Like a true pictorial poet, Magritte dissolves the untidy picture of the ordinary world into a number of vital factors and re-creates them on his chosen stage.

As to the title of this work, Renilde Hammacher–van den Brande has remarked, "We leave the established order to enter, with the painter, into the domain of the imagination. And the imagination means freedom."[35]

Bottom

Painted 1934

HOMAGE TO MACK SENNETT
(HOMMAGE A MACK SENNETT)

Oil on canvas, 28¾ x 21½"

Musée Communal, La Louvière, Belgium

Everyone is aware of the feelings that the clothes of someone we love can arouse. But it is not only the erotic that is involved, for the clothes of the dead often have the power of conjuring up their presence again. No one can say whether it is mainly the projection of memories, which take shape as an "image" through the clothes, or whether it is the clothes themselves, in all the various shapes the body molded them into, which touch one's sensual and visual nerve center.

This is a sober and quietly painted work. The door of a perfectly ordinary wardrobe, such as one can still find in depressing, shabby hotel rooms in small provincial towns, has been pulled open, and a life full of promise blossoms forth from the long, narrow woman's dress, which both conceals and reveals. A transparency has been created which has all the attraction and perversity of the ambiguous. There is an intimate atmosphere of twilight and boudoir secrets in this small painting.

Magritte took up the theme again at a later date in *Philosophy in the Boudoir* (1947–48), in a less intimate but more challenging manner in which the erotic element is more pronounced.

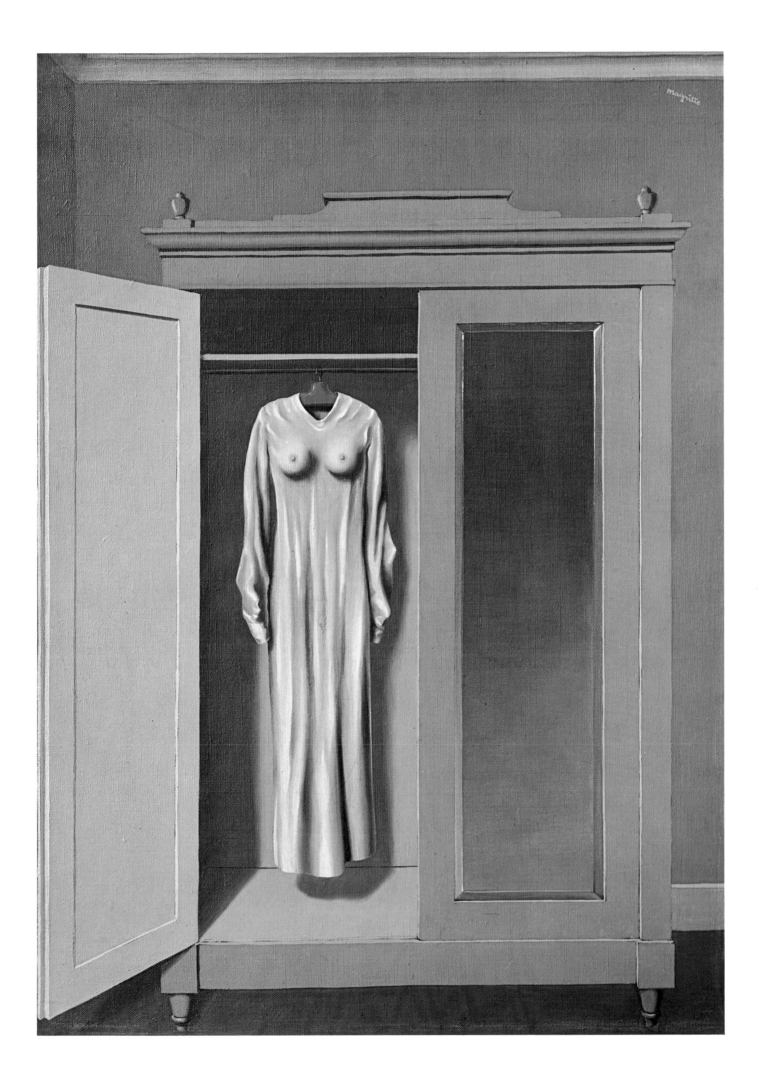

Painted about 1935

PAINTED PLASTER MASK

Height 12½"

Edward James Foundation, Chichester, Sussex

An important part of Magritte's imagination is the way in which he employed two or more manifestations of reality in the same "image." He slid one over the other, bringing them together within the same confines, and made two seasons, two times of day (such as day and night), two areas (indoors and outdoors, room and sky) coincide.

Here Magritte has painted over the image of Napoleon's familiar death mask to create the impression of a blue sky with clouds. Thus the mask has acquired a living quality which makes it stranger than when it was merely dull plaster. Moreover, Magritte has added space to conjure up a sense of vastness, reducing the tangibility of the sculpture but reinforcing the poetic dimension. It is a genuine transformation, based on the juxtaposition of the real death mask with a recollection of a sky with clouds—which is no longer a recollection, since, together with the mask, it forms a new poetic and spatial reality.

It has been suggested that Magritte presumably titled this work "L'Avenir des statues" ("The Future of Statues"). I have some doubts, for the image of the title is too close to the image of the object—something Magritte always tried to avoid.

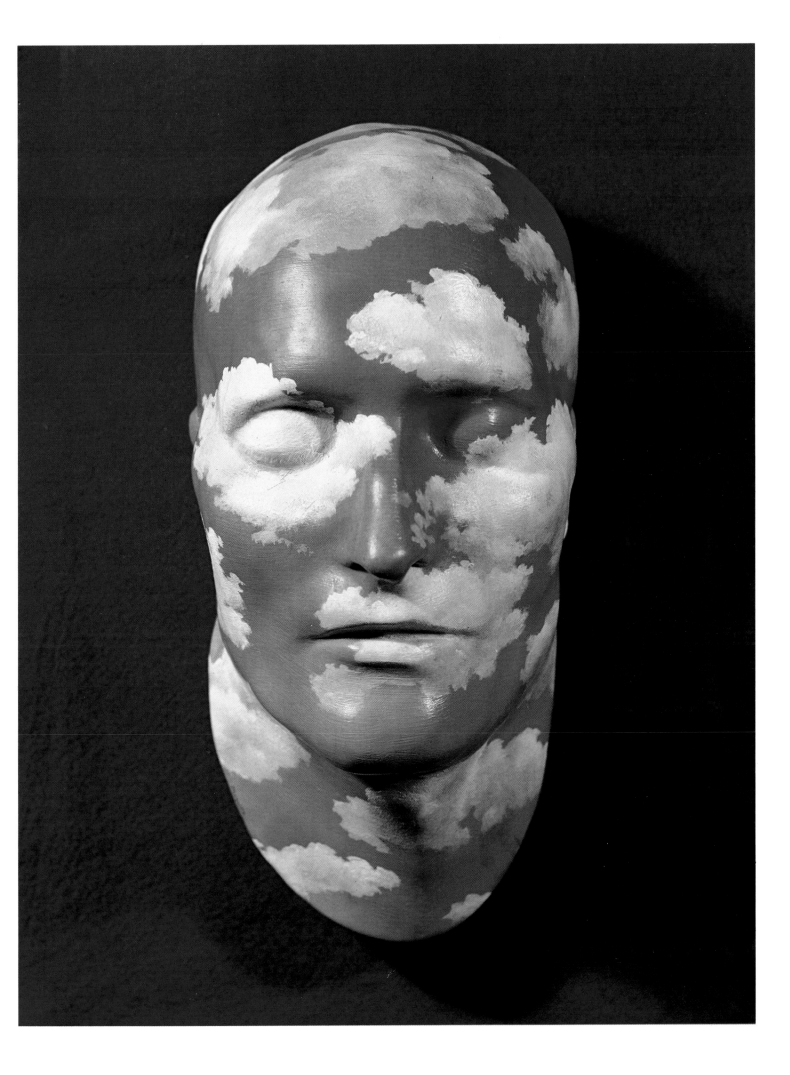

Painted 1935

ETERNITY
(L'ETERNITE)

Oil on canvas, 25½ x 33½"

Collection Harry Torczyner, New York City

Magritte has summarized here the appearance and atmosphere of a museum in three pedestals and a restricting red cord strung on copper supports.

In this work he has not made the spatial element ambiguous but has kept strictly to sensory reality and the illusionist method of painting. All he has done is to exhibit and isolate on the center pedestal a cylindrical lump of butter, with a wooden spatula stuck into it, to which a number has been given—reminiscent of the way butter was formerly sold in Flanders. The lump of butter is flanked by an impressive bronze head of Christ and a head of Dante.

An art historian would refer to Marcel Duchamp's urinal and to Man Ray's similarly challenging lavatory accessories to demonstrate the relationship between these works and Magritte's idea of undermining the sacrosanct character of works of art exhibited in a museum—which he has achieved by monumentalizing a chunk of butter and giving it the same rank in the hall of fame as is given the bronze heads of Christ and Dante.

Josef Beuys, the avant-garde German artist who has used butter as the main material for his work, can salute Magritte as the first painter to use butter not as part of a still life, but as a means of demonstrating a certain idea, as an attack on a form of culture, as an act of provocation. By changing the object on which adulation is lavished, Magritte has ridiculed it.

The extraordinary feature of this work is the impressive and utter seriousness with which Magritte has painted the heads of Christ and Dante as well as the butter. By this device he has created a resemblance which one finds difficult to accept. Michel Foucault, the French linguistic philosopher, does not rule out a certain devilment *(diablerie)* in this: "I cannot help thinking that the devilment lies in a process which the simple result has made invisible, but which alone can explain the vague embarrassment we feel."[36]

Bottom

Painted 1935

THE HUMAN CONDITION II
(LA CONDITION HUMAINE II)

Oil on canvas, 39½ x 28¾"

Collection Simon Spierer, Geneva

The painting within a painting has a long tradition, which Magritte restored and in a certain sense brought to an end by making us aware of indoor and outdoor spaces, which meet in his paintings. He himself put it in this way: "We see it [the world] as being outside ourselves, although it is only a mental representation of it that we experience inside ourselves. In the same way we sometimes situate in the past a thing which is happening in the present. Time and space thus lose that unrefined meaning which is the only one everyday experience takes into account."[37]

To the theme of the painting within a painting Magritte adds that of the window, placing it in the forefront. For him the window, which had played a role in painting since such German Romantics as Caspar David Friedrich, up to Matisse, had the significance of the eye in the body—which is the house, and from which one observes and experiences the world.

Although Magritte rarely gave us a complete landscape or figure, he almost always depicted a balustrade, a frame, a section of a wall, a windowsill, as though he required a support to protect him from becoming giddy. Magritte is always indoors, and from this vantage point he looks out into the unknown, into space and into life outside, at the same time listening to it. He is the "curtain man." Stripped of all support and logic that is usually provided by the windows and rooms which they serve, Magritte's curtains are the final relics, like the balustrades, like the window and door frames, which provide a link with the interior.

Another peculiar feature is the manner in which Magritte makes the sea seem real on the canvas and yet at the same time confers a transparency to it which exists only in the mind, for the sea on the canvas conceals the sea outside and beyond. From the purely technical and abstract viewpoint, the thin white vertical stroke representing the edge of the canvas is exceptionally finely balanced against the horizontal lines of the sea, the waves, and the boundaries of the floor in the room. The dark sphere forms the center, despite the fact that it is placed left and below the actual center; it is formally related to the arch of the door and the delicate screw on the painter's easel.

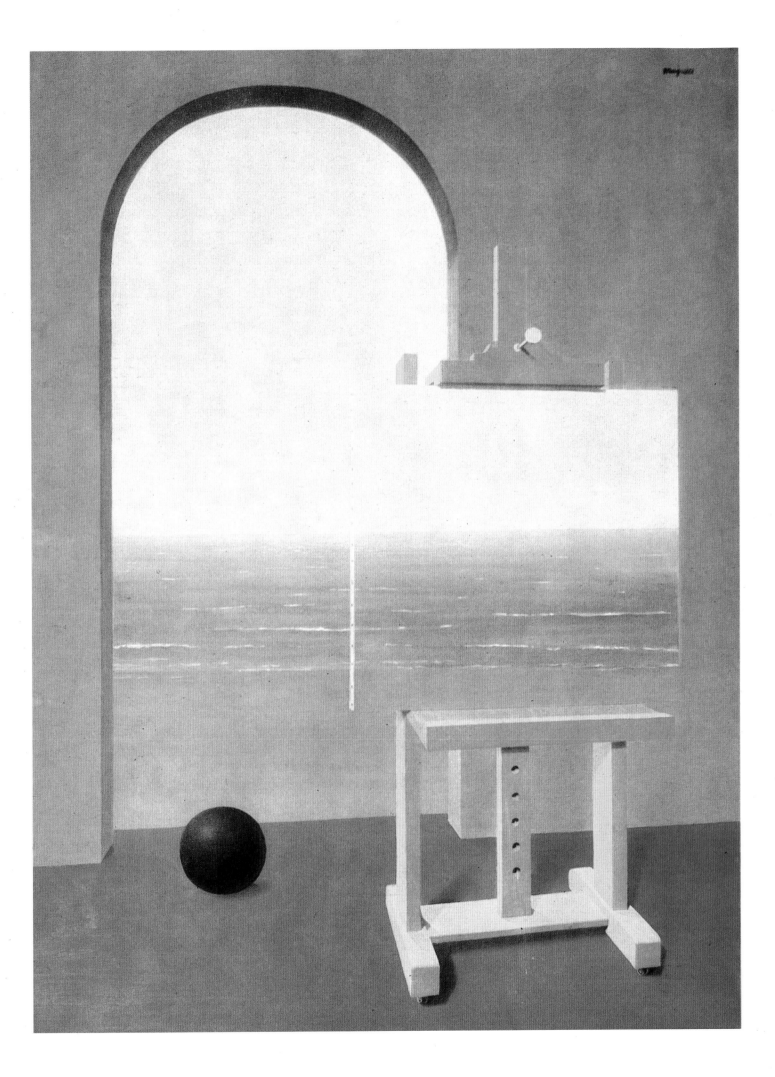

Painted 1936

THE BLACK FLAG
(LE DRAPEAU NOIR)

Oil on canvas, 20¼ x 28¼"

Scottish National Gallery of Modern Art, Edinburgh

E. L. T. Mesens, who played an important part in Magritte's life in the Surrealist movement in Brussels, London, and Paris, once wrote in reply to a questionnaire on the significance of poetry, "It is frightening to think that a poetic image like *The Black Flag,* a painting dating from 1936, more 'inspired' in this case than 'deduced,' was able to forecast pilotless aircraft. Poetry? Circumstantial magic? *A revolt against the state of reality?"*[38] (Italics added by the author.)

Like a Jules Verne, Magritte shows us pilotless aircraft steered by invisible means; the theme is unique in his oeuvre. The first, and also the last, impression the painting makes on us is one of a threat hanging over the world —a flight of dark, mechanical birds, omens of the horrors Hitler and Mussolini were to let loose over Europe.

Magritte would not be Magritte if these constructions, apparently intended seriously at first glance, did not on further inspection turn out to be playful objects that include a flying window, complete with curtains. The color is somber, hard, and menacing, and the draftsmanship of the constructions is as simple as it is relentlessly accurate. In spirit, the painting is one of the least "surrealist" of his works. It remains an exception, testifying to an inventive imagination affected by the preludes to the tragedy of 1939–45. The choice of the title is superb.

In 1937 Magritte made a gouache with the same title but different machines.

Painted 1937

THE RED MODEL II
(LE MODELE ROUGE II)

Oil on canvas, 72 x 53½"

Edward James Foundation, Chichester, Sussex

This is the second version, even higher in quality, of the canvas with the same title painted in 1935 and now in the Moderna Museet in Stockholm. Emile Langui mentions seven versions in the Marlborough catalogue, London, 1973.

Magritte painted the 1937 version for Edward James while in London, and to give it an English trademark he added a few English coins on the ground, at the left. On the right is a torn scrap of newspaper in which, as an illustration, he incorporated the earlier theme *The Titanic Days* of 1928, but in reverse (see colorplate 14). The scrap of newspaper bears French words: *inutiles, fumées, solitaires, malgré.*

The metamorphosis of the shoes, which become bare feet on the gravel that is evidently sharp and painful to them, concentrates our attention on their ambivalence: they are both shoes and at the same time bare feet. Magritte has isolated these shoes-feet in such a way that they become provocative.

In the commentary in *Les Beaux-Arts* of May 1, 1936, Magritte's friend Paul Nougé mentions a vague social criticism: *"The Red Model* utters a cry of alarm." Taking as his point of departure the pernicious influence which the social conditions imposed on us have on human relationships, Magritte wished to make clear that these perverted relationships also concern ordinary everyday things which we assume are at our service but which actually rule us, secretly and ominously—thus there is the power of shoes over men. Magritte himself commented that the daily contact of a leather shoe with the human foot was a barbarous and monstrous habit. Nougé's commentary reveals the artistic and political criticism of society inherent in the Surrealist mentality which is too often deliberately ignored.

In the painting here, together with the gravel, the unpainted planks with grained wood (always a favorite motif with Magritte and promoted by Max Ernst's *frottages*) create a primitive, harsh, and rough sensation, notwithstanding the refinement of the brushwork and the color tones.

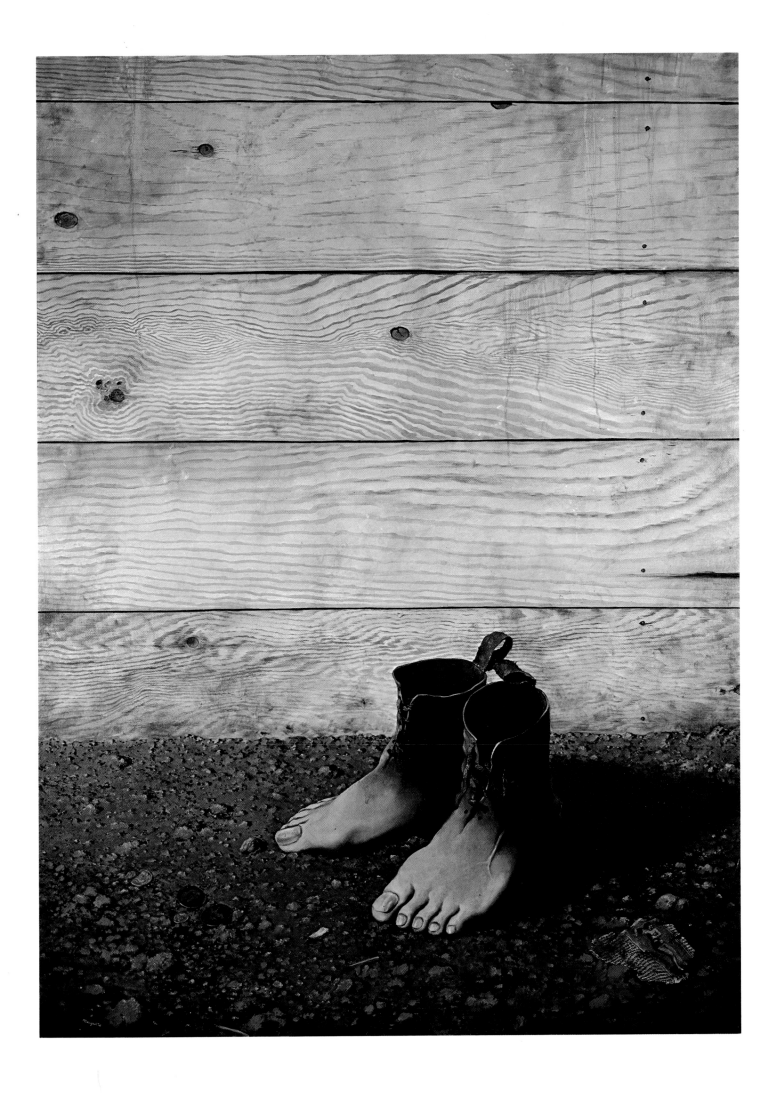

Painted 1938 or 1939

TIME TRANSFIXED
(LA DUREE POIGNARDEE)

Oil on canvas, 57⅝ x 38⅜"

The Art Institute of Chicago

Magritte represented a classic example of what Freud referred to as the mechanism of psychical repression—an idea Magritte himself rejected. Louis Scutenaire quotes Magritte as stating that "the element which was to be discovered, bound up more reconditely with each object than all the rest, was known to me in advance—as I found out during my researches—but it was a knowledge which seemed lost in the deepest recesses of my thinking."[39] He was searching, therefore, like a romantic in the lost paradise for knowledge already there but to be revealed anew.

Thus, in regard to a number of objects to which he stood in a certain relationship, he looked for a solution—that is, an insight, a special illumination—which would make it possible for him to conjure them up out of the darkness of his subconscious or unconscious and render them visible through painting. In doing so, he was not interested in small recollections of personal events in his life, but in the more general ability of memory to situate objects and events in a mythical paradise.

Of the locomotive in this work Magritte said, "As regards the locomotive, I have this charging out of the chimney opening of the fireplace in a dining room instead of the usual stovepipe. This metamorphosis is called *La Durée poignardée.*"[40] Note that Magritte himself introduced the idea of metamorphosis here. The title was for him "an image (in words) joined to a painted image."

The painting is strong, simple, and convincing in conception. The stovepipe has been transformed without the slightest hesitation into a charging locomotive. The mirror which is turned slightly to the front, two brass candelabra, the familiar black marble clock and the oblique angle from which we view it all lend tension to the picture and an unusual impact. What looks like a joke amounts to a mental leap, from chimney, stovepipe, coal, stoking, and smoke to the coal, stoking, and smoke of a locomotive. It is a leap from the external toward the internal world, via the comparison of two real objects. The fascination Magritte has for us lies in the way he reflects two realities—the inward and the outward—perfectly balanced, one against the other.

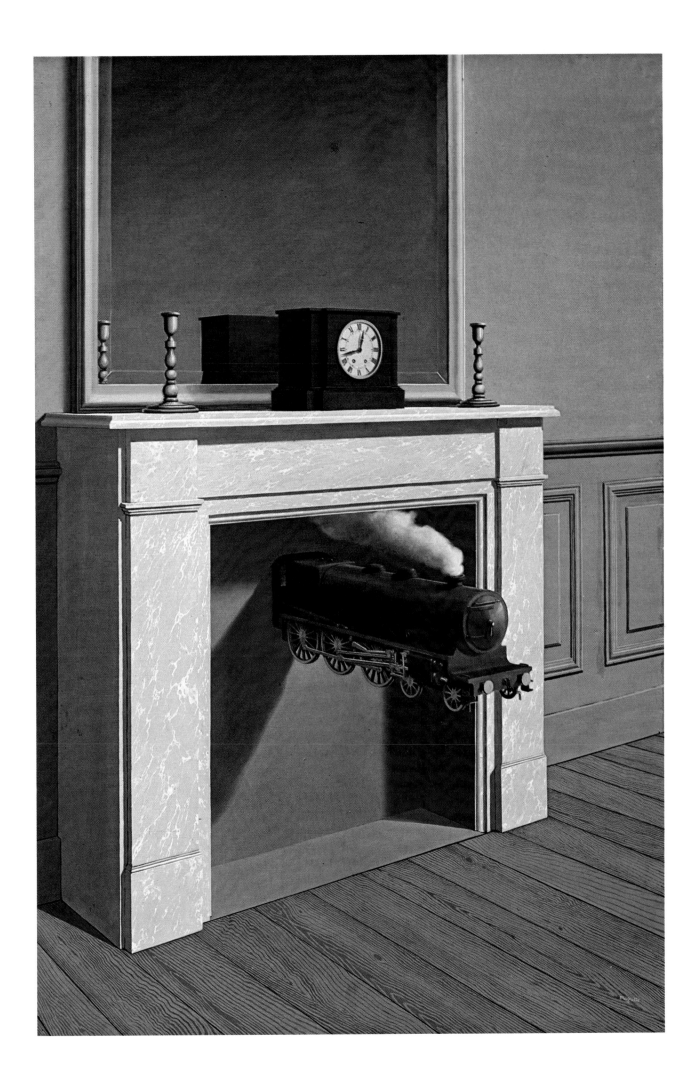

COLORPLATE 23

Painted 1937

MEDITATION

(MEDITATION)

Oil on canvas, 19⅞ x 25½"

Edward James Foundation, Chichester, Sussex

The sky, the sea, and the beach together form a normal view of the coast, yet they differ from nineteenth-century marine painting—by Delacroix, Courbet, or Daubigny, for instance—since in the almost midnight blue of the sea and the unnatural color of the beach particularly, Magritte has not kept to the appearance of things. His originality appears in the lower section of the work, where three lighted candles, which are also the heads of worms, curl their way across the beach. Recollections of dripping candles probably led him to discover their affinity especially with worms, as well as with reptiles, snails, wormlike eruptions in the sand, glowworms, and phosphorescent light on the water. The conjunction of reptile and candle so that they form a single organism is as unexpected and strange as it is simple.

One should not seek an interpretation in line with the limited logic of observed reality. Analogy is the operative factor; André Breton repeatedly invoked it as essential to poetry. In doing so, he quoted the poet and essayist Pierre Reverdy, who attached the utmost importance to the correlation of two realities with no ostensible connections between them, when it came to instilling force into the poetic image. To this Breton himself added the indispensability of the *analogous* image, which no doubt is the source of Magritte's imagery. The painting reveals the operation of the mechanism in the brain, which, guided by a capacity to discover relationships, succeeds in establishing relationships between images that are unconnected in nature.

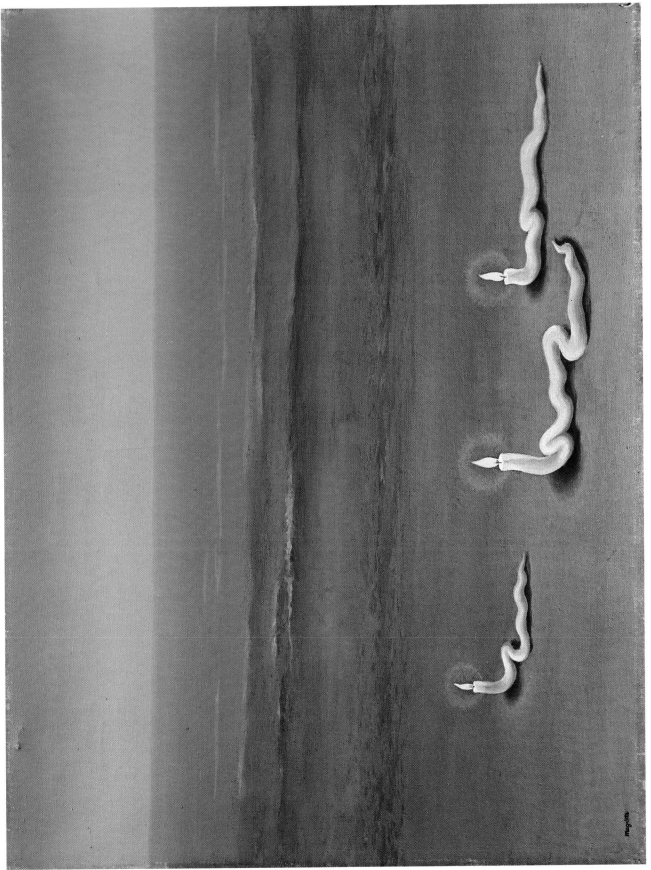

Painted c. 1934

THE EMPTY PICTURE FRAME

Gouache, 14⅝ x 16⅞″

Museum Boymans–van Beuningen, Rotterdam

In 1929 Magritte painted *The Spells of the Landscape,* representing a picture frame without a canvas, placed against a wall, with a title plate bearing the word *paysage* (landscape) on the frame; to the right is a rifle, also leaning against the wall.

What in ordinary language might have been called *The Empty Painting,* since all there is to see is a frame, is nevertheless entitled *Landscape,* the title plate taking the place of the missing landscape. Thus Magritte does not show us a landscape but a still life with a rifle and a picture frame.

The work illustrated here seems to be a painting within a painting which also shows us the wall of a room with a wainscot. There is scarcely any depth, only the wainscoting and the shadow of the frame. Thus we are given no knowledge of distance, height, or breadth. The painting is not empty, however, but consists of a framed brick wall, so real and so minutely detailed that we do not doubt that it is the outer wall of the gray inner wall. The cutting-off of this wall, without any foreground, makes the room seem strange and vague. It is the same sort of cutting-off that Magritte employs, for instance, in *The Waterfall* and in other canvases where a painting within a painting occurs.

The simultaneous appearance of a fragmentary inner wall and a framed outer wall, all within a single picture, is the reason why the presence of the inner and outer wall within a single space seems absurd and ephemeral. In a few instances Magritte used the irrational appearance of a brick wall in relation to a tree (*The Threshold of the Forest,* 1926; *Passionflower,* 1936).

Although everything about the painting is exact, the effect is abstract. This is indeed the world of ideas and no longer that of reality. Magritte has rarely made the artificial construction of an "image" derived from reality so taut, flat, and concrete as it is here.

The title remains a problem. Langui (Marlborough catalogue, London, 1973) gives *La Saignée,* translated as *The Blood-Letting,* which does not render the metaphorical meanings of the French word *saignée.* He dated it c. 1934. Mariën published it in his book with the title *L'Oiseau qui n'a qu'une aile* (1941). I have kept the title of the inventory of the Edward James Foundation: *The Empty Picture Frame.*

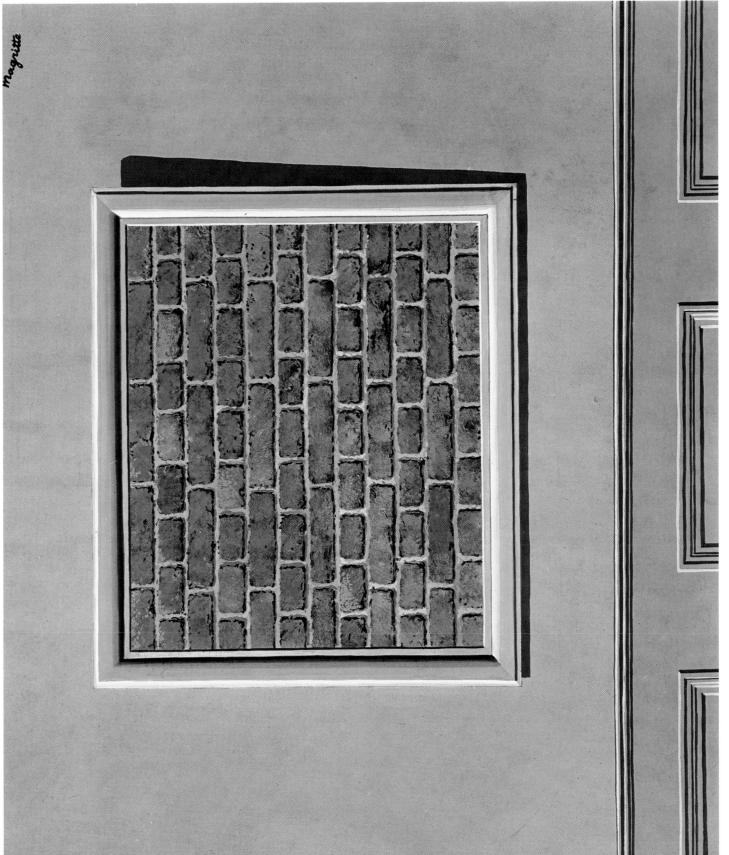

COLORPLATE 25

Painted 1939

THE GRADATION OF FIRE
(L'ECHELLE DU FEU)

Gouache, 10⅝ x 13⅜"

Edward James Foundation, Chichester, Sussex

In regard to this theme Magritte said that he was trying to put himself in the place of prehistoric man when he first discovered that fire resulted from striking two stones together.[41] He shows fire leaping up out of a piece of paper, a key, and an egg; and, as in other paintings, the large, upward sloping surface with grained wood plays an important part. An earlier painting of the same theme (formerly in the Mesens collection), in which the fire leaps up out of paper, a chair, and a tuba, was painted in 1933.

Magritte reminds us here of fire as an absolute phenomenon, which can originate from stones without devouring them. The egg, the key, the paper, the wood, the tuba, the sofa, used in relation to the flames of fire, seem for a moment as absurd as the stones which also give birth to fire. Magritte was fond of thinking in categories: light, air, fire, earth, rain, sun, window, sea, tree.

If *l'échelle,* or *la découverte,* of fire may be translated as *The Ladder of Fire,*[42] the reference is to every means or instrument by which we can create fire. Here, then, we see the miracle of the phenomenon of fire.

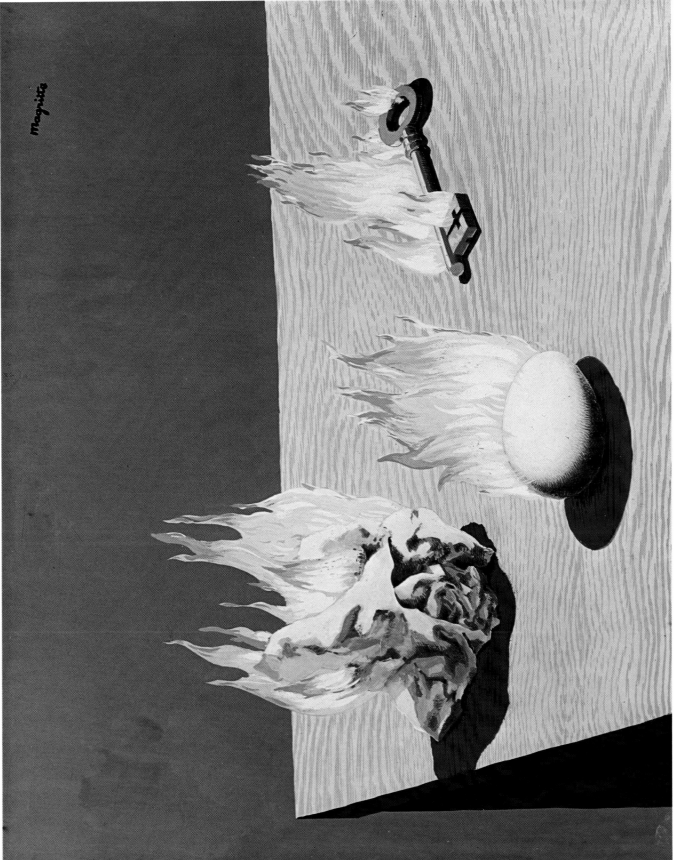

COLORPLATE 26

Painted 1939

THE POETIC WORLD II
(LE MONDE POETIQUE II)

Gouache, 10⅝ x 8⅝"

Edward James Foundation, Chichester, Sussex

In the English inventory of the works in the collection of the Edward James Foundation one reads, "Composition with Clouds and 'Pâté.'" Elsewhere there is a reference to "two pieces of pâté on a block."

Each object—sky, clouds, window, door, block, the two slices of pâté (one standing, one lying flat)—has been painted with complete realism; each is powerfully present and aglow with color, like objects on panels from the era of Jan van Eyck.

There is no deformation except in the relationships between things, in space, and in the proportions. The clouds transport us to space outside, although we are indoors observing the block with the pâté, while the clouds inside the room are of proportions proper for a still life. Yet, nothing surprises us because the antithesis of outdoors and indoors in this image has been transformed into a new order of being, light, and space which can have been created only by the imagination. The unmistakable clarity and tension in the new scene before our eyes are achieved by the sublime blue, white, and deep gray, which together compose an intense and radiant light. This light provides a new unity to which all things are subordinate and yet which can only reveal itself to us via the objects.

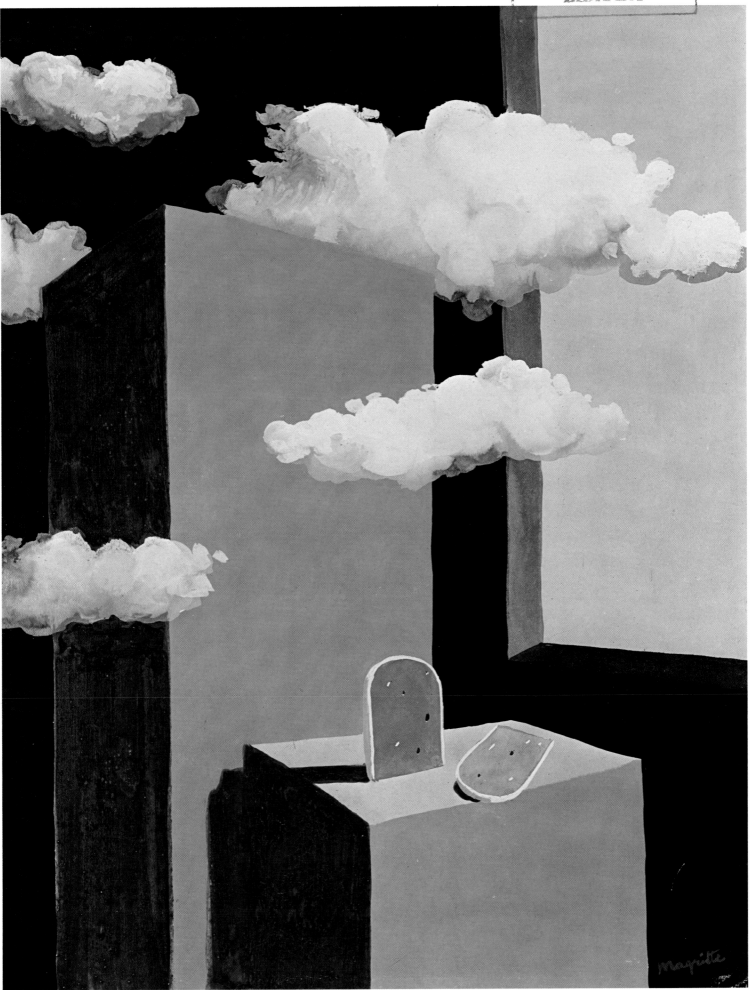

Painted 1939

GOOD FORTUNE
(LA BONNE AVENTURE)

Gouache, 13¼ x 16"

Museum Boymans–van Beuningen, Rotterdam

Magritte painted a number of variations on the theme of the simultaneous appearance of day and night under the title *The Empire of Lights*. This gouache, *Good Fortune,* represents the same motif.

This series lends itself well to the art historian's method. There is, for example, a striking resemblance between the effects of *Good Fortune* and a number of paintings from the early Symbolist period by a fellow countryman of Magritte's, William Degouve de Nuncques, with the difference that the essential feature of Degouve's work is not present in the work of Magritte, who presents his mental fantasy by means of the romantic effect of evening light, whereas Degouve achieves only a heightened effect of mood.

It is also tempting to trace a relationship with the German Romantic artist Caspar David Friedrich, and this comparison invites deeper investigation. The modernity of twentieth-century Surrealism in Magritte's work sometimes causes one to doubt that deep in Magritte's being the romantic bent, in its larger meaning, was dominant. Works such as this one strengthen this conviction. Magritte never saw actual paintings by Friedrich, but he became highly interested in him through books and illustrations of his work.

In 1964 André Breton contributed an introduction to an exhibition of Magritte's work in Houston, Texas, in the final lines of which he wrote about one of the variations on *The Empire of Lights* theme as follows: "To attack this problem called for all his audacity—to extract simultaneously what is light from the shadow and what is shadow from the light. In this work the violence done to accepted ideas and conventions is such (I—Breton—have this from Magritte) that most of those who go by quickly think they saw stars in the daytime sky."

The gouache illustrated here is an unusually fine and early solution to the problem of fusing night and day to form a single landscape. The delicately branched winter tree set against a luminous sky with dark clouds, and the stars and crescent moon covering the houses are linked to the sharp silhouettes of these houses, in whose windows gleams lamplight. Thus, in an apparently simple evening landscape, Magritte summarizes a wealth of experiences of light in three categories which are separate and distinct in time. Of one of the paintings in this series Magritte himself said in simple terms, "This evocation of night and day seems to me to be endowed with the power to surprise and enchant us. This power I call poetry."[43]

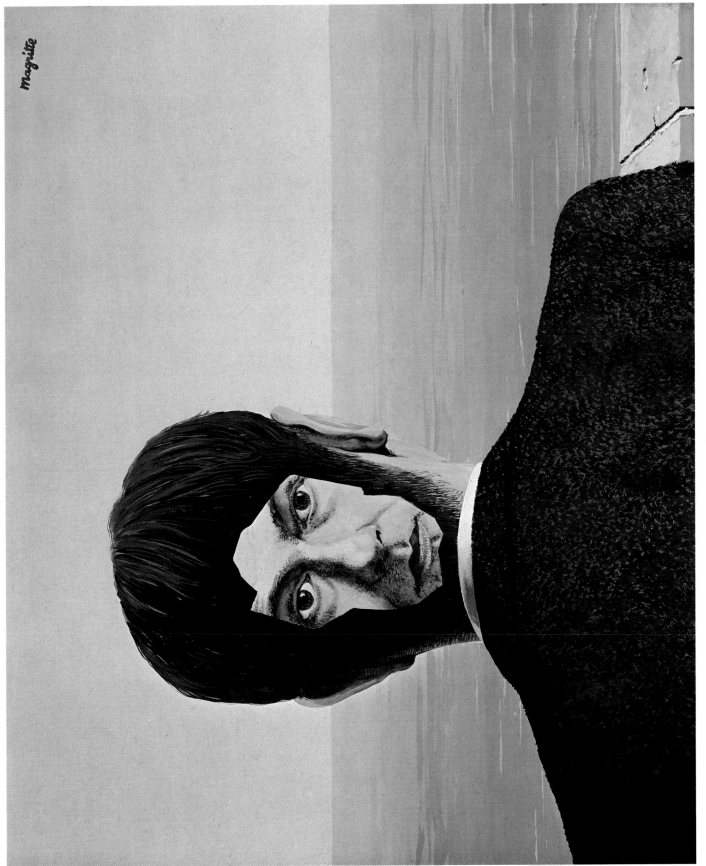

Magritte

COLORPLATE 29

Painted 1939

POISON

(LE POISON)

Gouache, 14 x 16"

Edward James Foundation, Chichester, Sussex

Magritte played endless games with the mystery of space and time to which earthly things are subject. His means included the fusion of interior and exterior and the alteration of proportions. Without interfering with the shape of things, he interfered with the system of things (poison interferes with an organism, a nervous system, a system in equilibrium), and he relativized the concepts "big" and "small." A cloud comes sailing into a room through the door, where it becomes an object casting a shadow on the wall. But the cloud also belongs to the sea and the sky outside, which are visible through the half-open door. There is an invisible observer; he might be a person supposed to be in the room who experiences this fusion of spaces, or the painter himself and the viewer of the work. The door shows an improbable change of color, beginning at the bottom with the color and grain of bare wood and changing higher up into a luminous, transparent blue that is the color of the sky above the sea outside. The result is that the natural scene outdoors and the room indoors merge into each other, transcending any spatial contradiction and losing their individual character. At the same time there is an inspired and poetic insight from this new concept of space which defies formulation in words.

Magritte's vision is intimately bound up with the spirit which inspired André Breton and his militant, strongly contested second Surrealist Manifesto. Breton had his text for this ready in October 1929 (the same year in which Magritte, René Char, Luis Buñuel, and Salvador Dali were admitted to the Surrealist group). Of this André Thirion says, "It was gold, which returned in cartloads. It was a capital event. All the political alarms were exorcised."[44]

"The limit at which contradictions cease to be noticed"—this phrase from Breton's second manifesto is especially applicable to Magritte's metamorphosis of space.

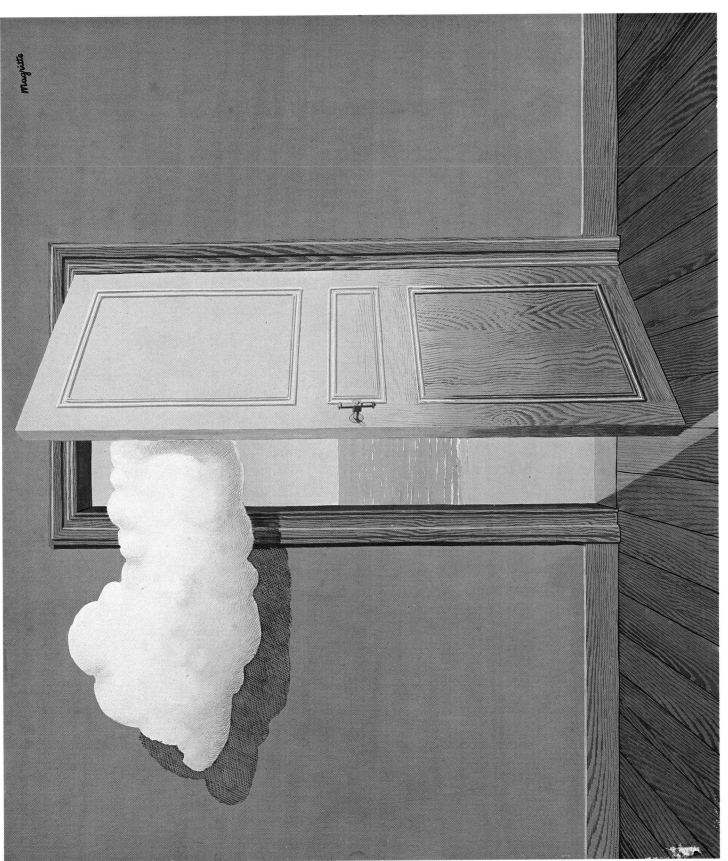

Painted 1945

NATURAL ENCOUNTERS
(LES RENCONTRES NATURELLES)

Oil on canvas, 31½ x 25½"

Collection Louis Scutenaire, Brussels

The experience of this painting can be like a strange encounter. First and foremost, there is the soft violet color of the wall's surface which dominates the entire canvas, becoming warmer and deeper near the bottom in the floor and in the purple-red tones of the two odd mannequins.

The cutoff at chest height of the two bilboquet-mannequins and the absence of any converging lines creating perspective make it impossible to gauge the distance of the figures from the wall or the dimensions of the room. Converging lines appear only in the window frames. The left-hand window is seen from the right, the right-hand one from the left, and the latter also appears to have slipped down at an angle; the fall is accentuated by the horizon of sea and clouds, visible through the window. This is almost the only suggestion of a world outside, of a third dimension, which is indicated inside the room solely by the two moon-pale mannequins—two strange "halfway creatures" with the eyes of animals and small snouts—and by two strange windows which have lost their normal fixed relation to the wall through the collapse of the right-hand window. This is a world which has become insecure and labile, in which neither the window nor the wall itself collapses, although the relationship between them is ambiguous. The wonderful feature of this canvas lies in the bright daylight of the real world beyond us, isolated and visible in a concentrated way within the rectangle of the upright window.

Thus the "encounter" is not between the two mannequins, not between the viewer and the picture, but between the exterior and interior worlds. This is precisely where Magritte is always at his best—the level at which contradictions do not cease to exist but lose their significance, because, in a moment of illumination, we descend so deeply into ourselves that we begin to participate in the meeting of these two worlds.

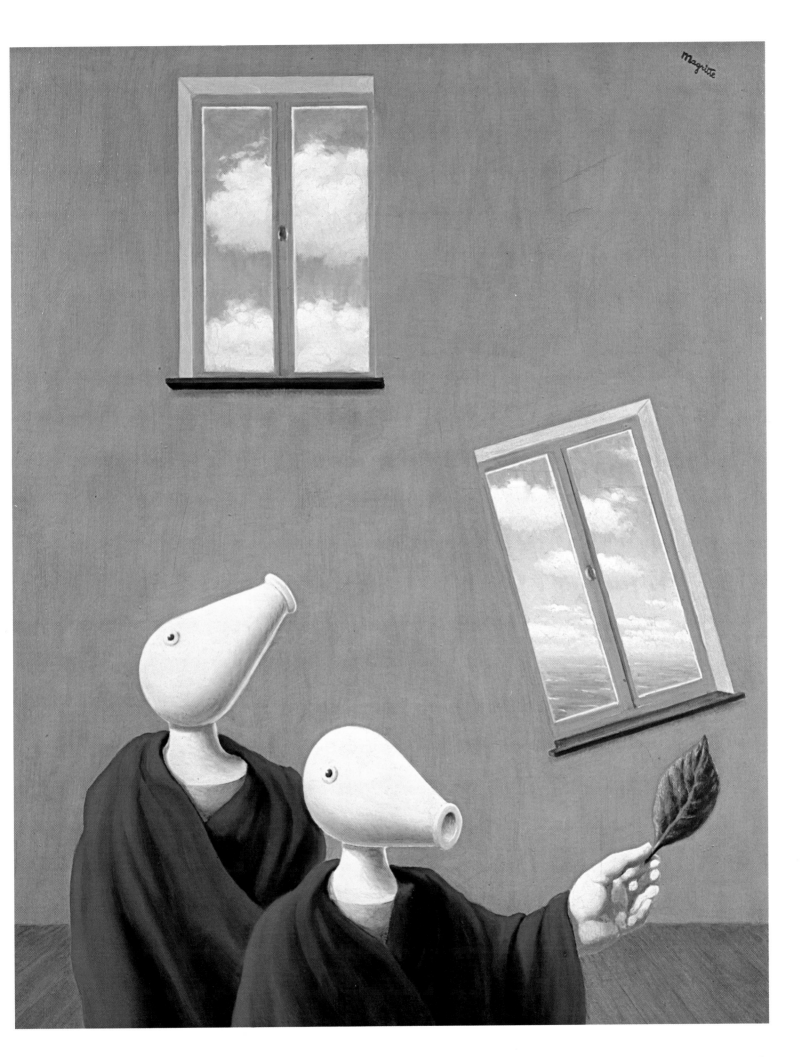

Painted 1949

PERSPECTIVE: THE BALCONY BY MANET (PERSPECTIVE: LE BALCON DE MANET)

Oil on canvas, 31½ x 23½"

Museum voor Schone Kunsten, Ghent

What was it that induced Magritte to transform the famous painting by Manet of 1869, showing a balcony in Spain occupied by Manet's charming lady friends and a portly gentleman, into a motif where the figures have been replaced or concealed by coffins? The observer cannot banish from his memory the work of Manet, which is so well known through reproductions and advertisements, and his impression is a mixed one. The memory of the picture with the living figures blends with Magritte's invention, the coffins.

Like Poe, Magritte was fascinated by death throughout his life, beginning with the experience of his mother's suicide by drowning while he was a boy and then his perverse attraction to playing in the graveyard at Soignes. This fascination revealed itself on two later occasions in a grotesque and macabre manner. During a visit to a friend who was a coffin maker, Magritte spent an afternoon in a magnificent coffin, with a sliding window in the lid which left the face of the departed visible. But the experience did him no good, for what had begun as a joke ended a week later in fits of nervous anxiety. Magritte's other macabre joke was to invite friends to his house at a time when, as circumstances would have it, a deceased policeman was lying in state in the room next to Magritte's bedroom.

To Magritte the coffin was an object which had irresistible appeal for a variety of reasons (though this interest has nothing to do with a canvas by Antoine Wiertz entitled *The Precipitate Internment*).[45] Particularly important is Magritte's intimate acquaintance with the numerous passages in the stories of Edgar Allen Poe in which death and life after death form the main theme.

The shock one receives on first seeing this work is of surprise that a painter should want to transform human figures into rigid, carefully executed forms of coffins. In other words, the spectator is confronted with the lugubrious idea of death and an obsession with the process of mortality. But in the perspective of mortality, the very charm of life becomes apparent.

After creating this work and another suggested by David's attractive portrait of Madame Récamier of 1800 where the figure is again replaced by a coffin, Magritte produced his own variations of the seated coffin or of coffins on balustrades, but in the later works the idea has a weaker effect, since there is no longer any reference to recollections of a well-known painting.

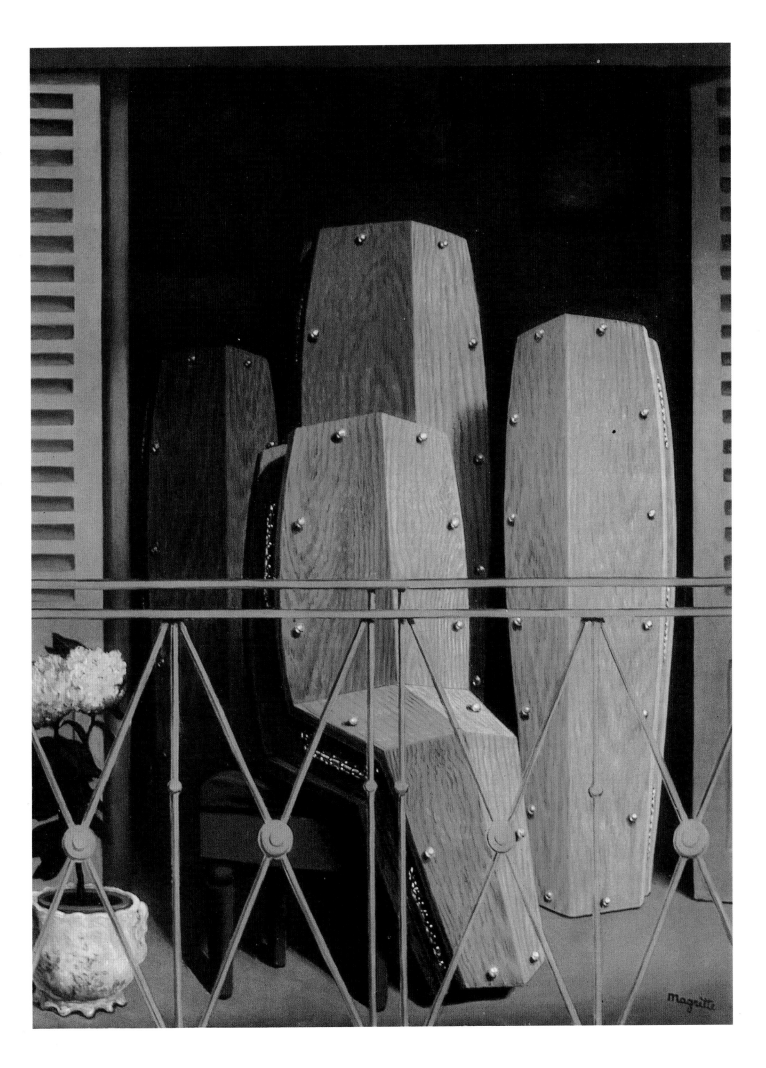

Painted 1951

RECOLLECTION OF TRAVELS III
(SOUVENIR DE VOYAGE III)

Oil on canvas, 33 x 25½"

Collection Adelaide de Menil, New York City

Magritte's "Stone Age" set in shortly after the outbreak of World War II (when he made birds and leaves of stone), but it was not until the 1950s that it attained its full and truly impressive proportions—the same period that coffins (including *Perspective: The Balcony by Manet,* colorplate 31) appear in his work. His fascination for stone ranged widely. *The Domain of Arnheim, The Castle in the Pyrenees, The Art of Conversation* (with variations) are less directly related to the process of petrifaction than are *The Song of the Violet* (fig. 40) and the *Recollection of Travels* series. In this series the process embraces the whole of life, descending upon it as the streams of lava once descended on Pompeii; in Magritte's case, it is the memory's lavastream.

In *The Castle in the Pyrenees* (colorplate 35) he has altered the laws of gravity and the behavior of matter, but space, and the landscape, continue to breathe. In *Recollection of Travels* nothing has changed in the natural aspect of people and things except the materials they are made of. Because everything has become petrified, transfixed as in a monument, there is a terrible impression of all breathing having come to a stop. Here the word "souvenir," a prominent component of all works of the Romantic era, acquires an almost cynical—and, in any case, ironical—intonation.

Human memory has been swept up into the mystery of life that has been brought to a halt, but even the petrified wears away and disappears. It is not mere coincidence that during the same period Magritte also encased the living in coffins—that is, removed them from direct sight.

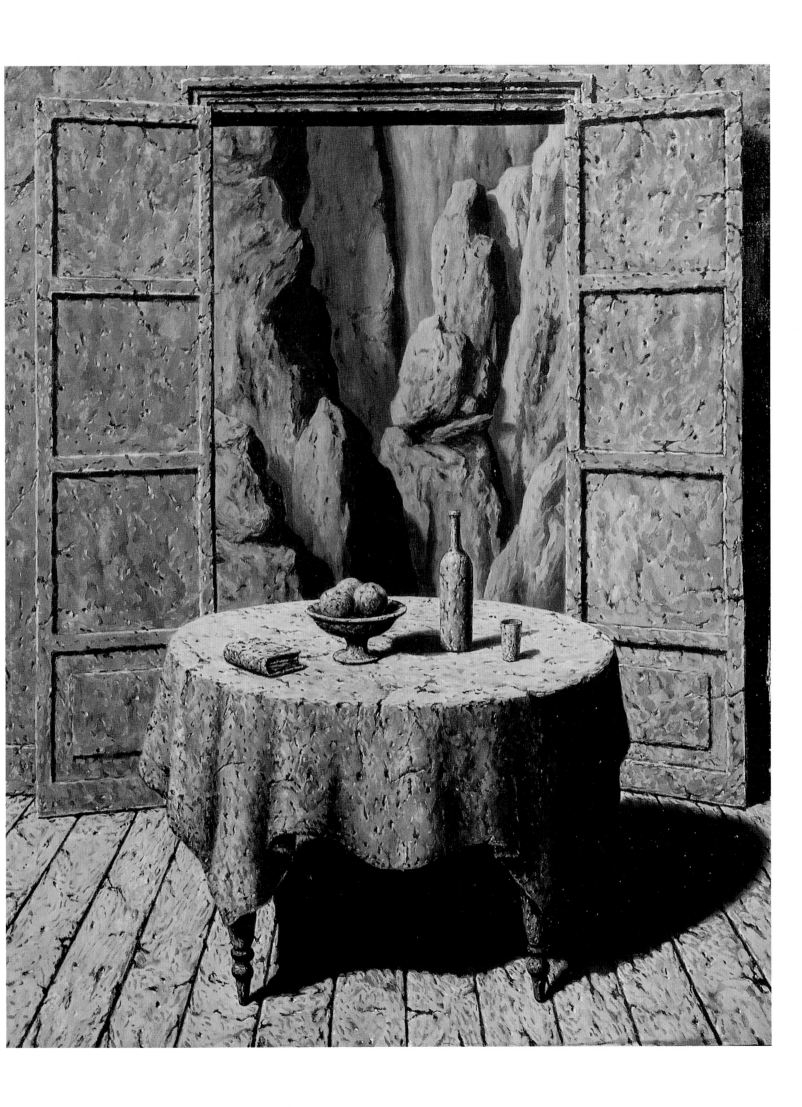

Painted 1952

PERSONAL VALUES
(LES VALEURS PERSONNELLES)

Oil on canvas, 31⅞ x 39½"

Collection Harry Torczyner, New York City

It is an exception that the title in this case can be taken to refer literally to the objects portrayed—shown here in a bedroom.

Magritte has changed the proportions between these objects to such an extent that between the smallest object in the real world—the match—and the largest pieces of furniture—the cupboard and the bed—they have almost been reversed. The comb has assumed gigantic proportions, the glass has become as tall as a human being. Moreover, one is able to imagine the walls of the room as transparent, until one notices the shadow effect of one corner, where the right wall meets the main wall, the cupboard on its left also casting a shadow, as well as the comb. In other words, the transparency is unreal.

I have seen this work repeatedly and have always been obliged to conclude that this game with changed proportions is so convincing that one accepts it. An important contributing factor here is the tranquil manner of the painting itself, which is reminiscent of Italian interiors of the early sixteenth century, because of both the splendid sky with clouds and the double bed. One thinks particularly of Vittore Carpaccio. Magritte's painting has something of the same clarity, profundity, and peace. Actually the most surprising feature of all is the realism of the static light and a luminous sky, which pierce the protecting walls and unite only in dreams.

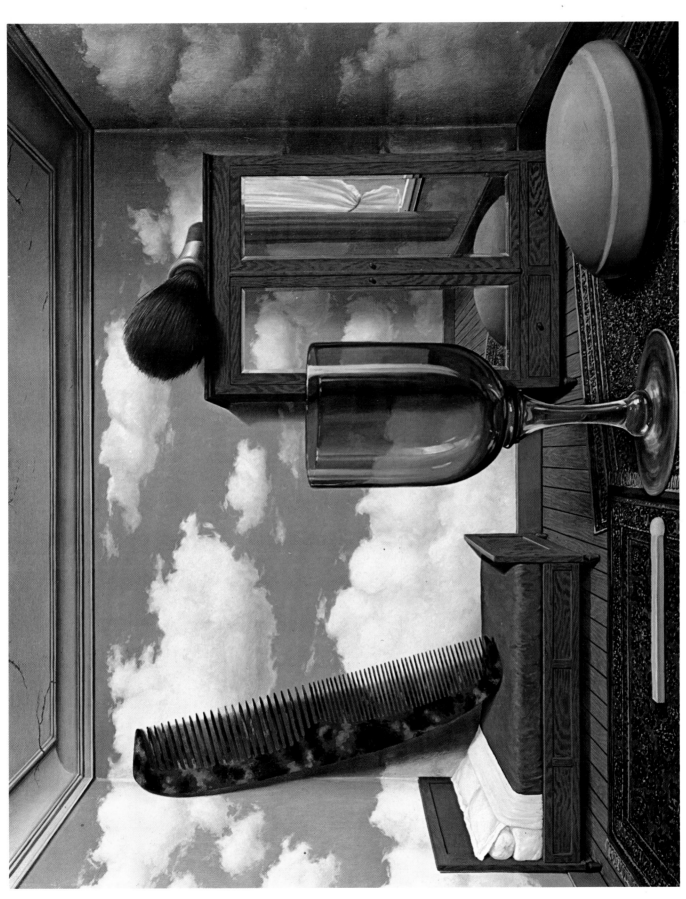

Painted 1957

SEPTEMBER 16
(LE 16 SEPTEMBRE)

Oil on canvas, 63⅜ x 51¼"

The de Menil Foundation, Houston, Texas

Like the bilboquet-mannequin, the horse's harness bells, the bowler hat, and the curtains, wood and trees are objects Magritte employed throughout his work. In the few lectures he gave, he even made specific references to them: "As a problem object, the tree became a large leaf, the stalk of which was a trunk, planting its roots straight into the soil. With a poem of Baudelaire in mind, I called it 'La Géante.' "[46]

Suzi Gablik quotes Magritte as follows: "Growing from the earth towards the sun, a tree is an image of certain happiness. To perceive this image we must be immobile like the tree. When we are moving, it is the tree which becomes the spectator. It is witness, equally, in the shape of chairs, tables and doors, to the more or less agitated spectacle of our life. The tree, having become a coffin, disappears into the earth. And when it is transformed into fire, it vanishes into the air."[47]

In Magritte's work of the years 1925 to 1930, the woods are somber, wild, compact, convulsive, and the trees are not of the kind which Gaston Bachelard associates with the house, the birthplace, maternal protection. It is only years later that Magritte makes a hollow in the tree and conceals a house inside it, and it is difficult to read Bachelard on this subject without seeing one of Magritte's inhabited trees. Bachelard alludes to Bernardin de Saint-Pierre: "But at the heart of the tree the reverie is immense...my protector is almighty. He defies the storm and death. It is total protection....From the heart of a hollow tree, at the center of the cavernous trunk, we have followed the dream of an anchored immensity."[48]

In the work depicted here, Magritte has attained the immobility which makes it possible for him to experience form inwardly. Out of this immobility grows silence, the mysterious silence in which the darkness of the tree, painted in all its details precisely as Caspar David Friedrich would have painted it, develops from intimacy to immensity. Now Magritte is the complete Romantic, who makes night seize upon the space occupied by the tree. He places the moon not above, beside, or behind the tree, but in front of it. And this is the one sign that shows us that we are not in the presence of a nineteenth-century painter. The names of poets like Novalis and Rilke occur to us. The title was invented by Scutenaire.

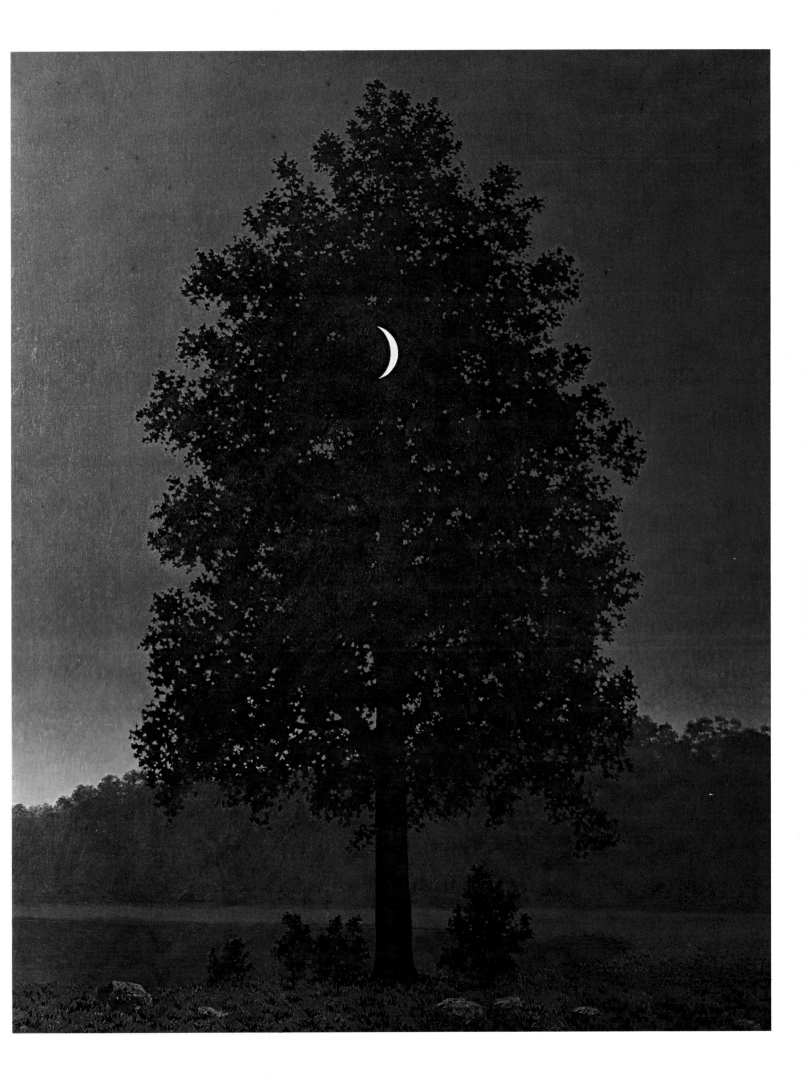

Painted 1959

THE CASTLE IN THE PYRENEES
(LE CHATEAU DES PYRENEES)

Oil on canvas, 79 x 55"

Collection Harry Torczyner, New York City

Although there were traces of Magritte's fascination with rocks before and after, the period of his great imaginative productivity which concentrated on the process of petrifaction and on the properties of stone was the 1950s. It might be termed the artist's "Stone Age." The somber *Recollection of Travels (I–III)* series (colorplate 32 and 40), *Intimate Journal, The Song of the Violet* (fig. 42), and the bold painting *The Pledge (La Parole donnée)* belong to 1950–51. A change occurred in 1953–54, with the disappearance of somber tones and an atmosphere of oppression. In 1958–59 particularly, Magritte was obsessed by the volume and weight of enormous rocks, but he altered the laws of gravity and disregarded the weight of matter; for instance, he had a rock sink or rise, or had it rest near a sleeping person—an eternal sleeper in a tilted, open coffin on legs (in *The Hour Will Strike,* Nellens Collection).

To his vision of a castle on a rock floating above the sea Magritte gave the title *The Castle in the Pyrenees,* apparently a play on the French expression *"châteaux en Espagne"*—equivalent to "castles in the air." Magritte painted this work in blues, grays, and off-white, in that cool, finished manner by which he made the imaginary look real. The vision he must have had of the aerial journey of a castle on the cliffs emphasizes his close relationship to Edgar Allan Poe, who, in his story "The Domain of Arnheim," after a precise description of a journey through an unreal landscape, has the massive structure of "semi-Gothic, semi-Saracenic architecture, sustaining itself as if by miracle in mid-air" loom up over everything. It is indeed the experience of living "in mid-air" that Magritte has evoked in this painting.

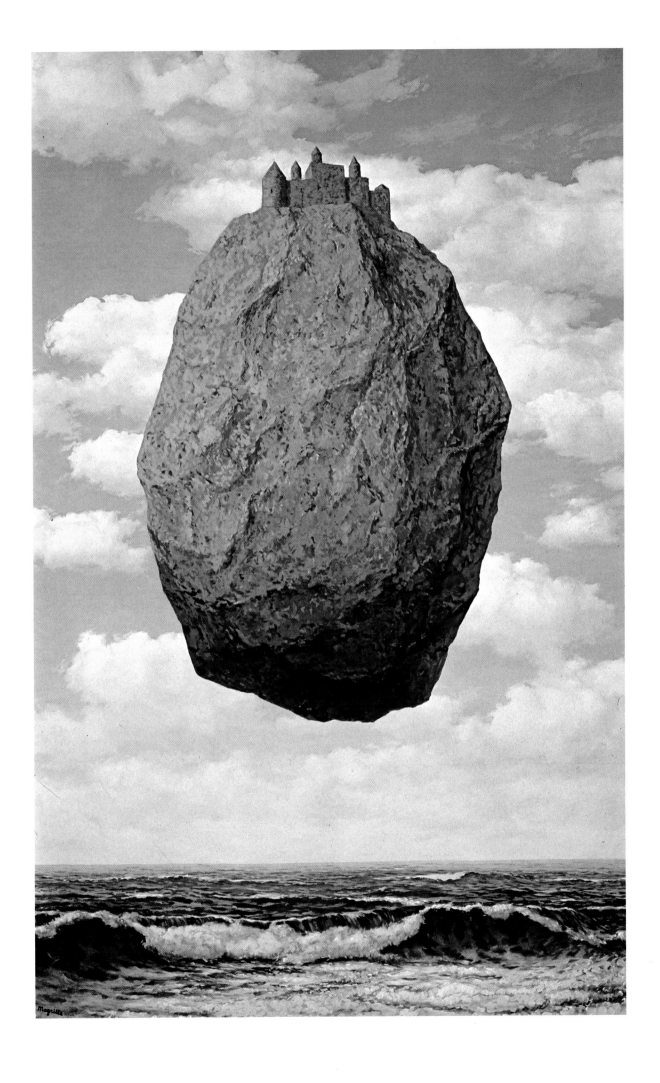

Painted 1960

THE TOMB OF THE WRESTLERS
(LE TOMBEAU DES LUTTEURS)

Oil on canvas, 35 x 46⅛"

Collection Harry Torczyner, New York City

A relatively late painting, this work resulted from an exchange of letters resulting in a commission, as was often the case with Magritte. Despite the post-Romantic tradition according to which the artist, entrenched in his social isolation, tended increasingly to frown on commissions, Magritte never scorned them. In this respect he was a medieval man—in any event, not the man to stand on his dignity as an artist, although he did at times give way too much to the pressures others put on him.

The title *The Tomb of the Wrestlers* was inspired by the novel of the French Symbolist writer Léon-Alpinien Cladel, *Ompdrailles, le tombeau des lutteurs* (1879). The painting is not merely the result of a commission from Harry Torczyner, but of an exchange of ideas and letters in which Magritte indeed retained his artistic freedom. The rose was a theme which had fascinated him from his earliest period on. As early as his Cubist-Futurist experiments, when he had painted a rose in the place of the heart on a female nude for which his wife sat as model, Magritte had remarked that it had anything but the exciting effect he had hoped it might. The rose had remained too subordinate an element in the composition. Henceforth more emphasis was laid on it as an object. His new point of departure was "to go beyond the level of images and bring the real world into things."[49]

Magritte often thought of making a painting of a skeleton plucking a rose in a magnificent garden at night under a sky of stars.[50] Something always restrained him from doing this, however. But he did paint a rose on a lamppost, in a scene of great poetic charm.

Altering the normal dimensions of things was one of Magritte's ways of relativizing spatial concepts. The relative proportions of objects change to such an extent that the viewer of his works is forced to free himself from the bonds which the conventional presentation of things imposes and, by so doing, to experience them anew and more deeply.

The marvelous thing about Magritte's rose is that it fills the room from floor to ceiling with its glowing sensuality without making the room look absurdly small. In other words, as a presence in a room with its odor, color, and shape, a rose can be such a challenge to the viewer that it takes possession of his secret thoughts and emotions. As a result, an inner image of the rose emerges which irresistibly absorbs the space it occupies without interfering with it.

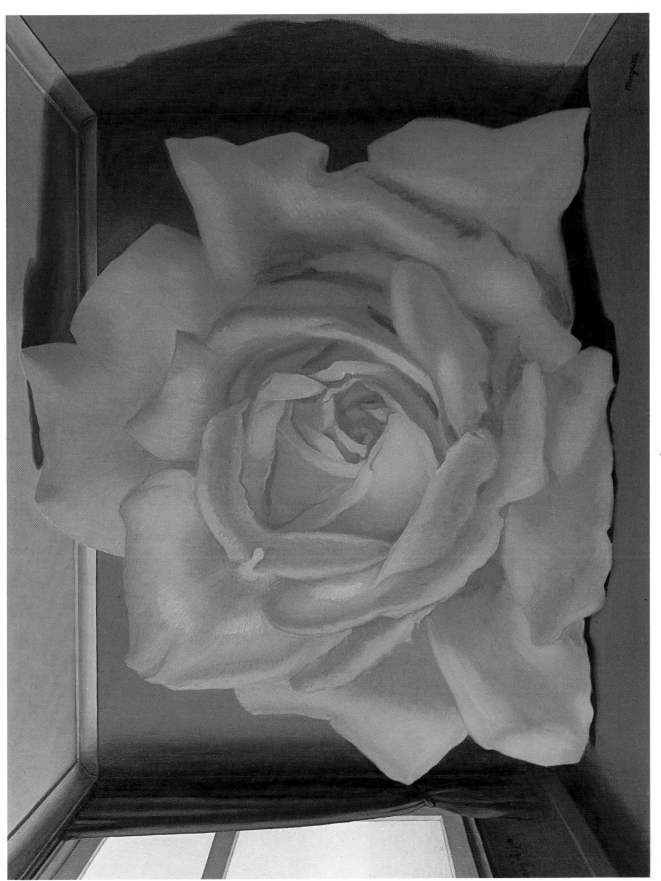

Bottom

Painted 1962

THE DOMAIN OF ARNHEIM
(LE DOMAINE D'ARNHEIM)

Oil on canvas, 57½ x 44⅞"

Collection Mme Georgette Magritte, Brussels

The title of this work comes from Edgar Allan Poe's incomparable tale "The Domain of Arnheim," with its description of an imaginary landscape, yet the painting did not result directly from Poe's landscape. At the same time, one assumes that Magritte's choice of title must have depended on his realizing that Poe's imagination was related to his own. In other words, without his having been aware of it at the time, Magritte's repeated absorption of Poe's stories had left a residue of the American author's ideas in his mind.

Magritte is not, therefore, illustrating the story "The Domain of Arnheim," which did not include either a bird's nest or a mountain eagle. He has transformed an undeniably grand impression of a moonlit mountain landscape by means of a mental technique related to that of Poe and his imaginary friend Ellison, who described a magnificent, complicated, and weird landscape in which the natural phenomena have been retouched by the spiritual intervention of superior beings. It was not by God nor by an emanation from God, but, according to Poe, by the hands of angels existing between God and man. Magritte had begun to reshape a mountain to a bird's image in 1933–34. Even then he had Poe's story in mind. Yet *The Shadow's Wreckage*, undated but looking much earlier (before 1930), shows a similar shape.

Without the suggestions from Poe's story Magritte might never have seen the eagle as an adjustment to—or a metamorphosis of—the line of mountain peaks, rising out of them and surveying the land, nor might he have seen the three small eggs in the nest on the stone balustrade. A work which just avoids the pitfalls of kitsch, this is a landscape in which the sublime recollection of a moment of powerful emotion was painted scrupulously with a reticent adjusting touch.

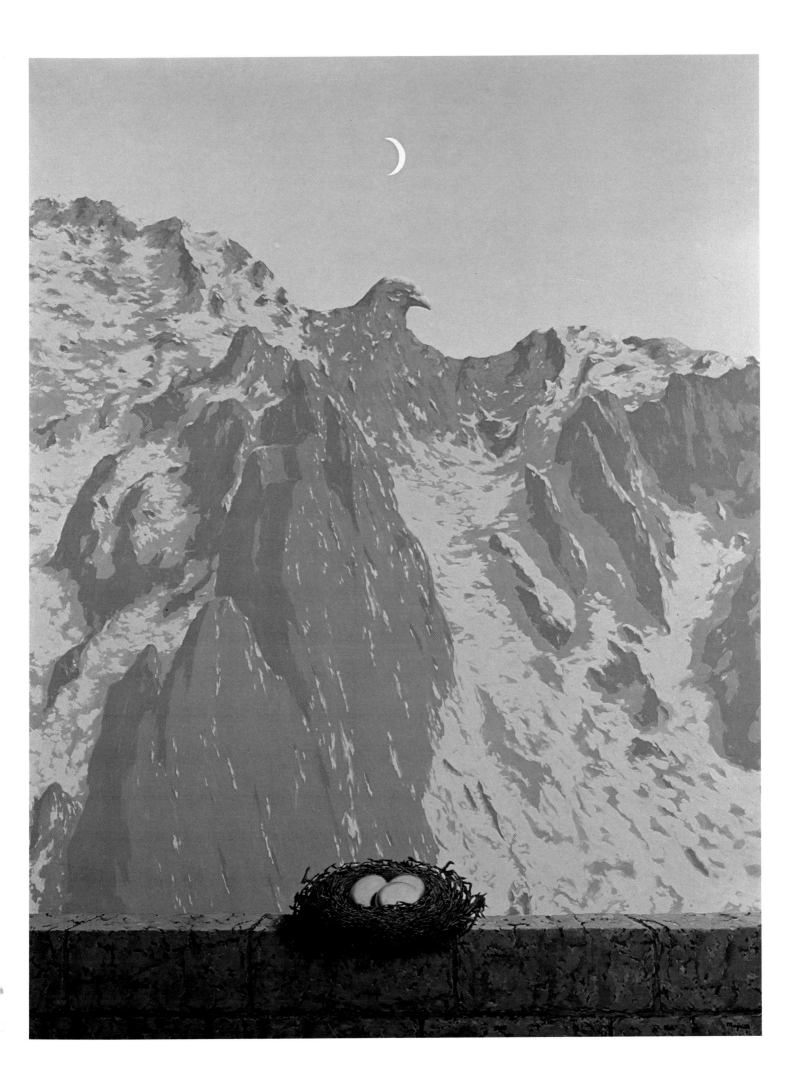

Painted 1962

WASTED EFFORT
(LA PEINE PERDUE)

Oil on canvas, 39 x 31¼"

Collection Harry Torczyner, New York City

Blue fascinated Magritte during his entire career. This color began to emerge after 1926, when it had a different emotional quality; about 1936 Magritte achieved transparency, lucidity, and depth in very faint blues.

Wasted Effort is a fairly late and complicated imaginative composition in blues. Much of earlier work is present—even the ball with the slit in it, the transformed offspring of the horse's harness bells. The mighty sky with its fleet of clouds—which would form a background, if they did not appear again where we find the cut-out curtains or theater wings—has undergone a change of tone. One no longer thinks of reality when seeing this triple version of clouds. Here Magritte has achieved a symphonic orchestration of something remembered, calling it "clouds and sky." On either side of the gray-blue plain of the stage—for that is what it is—stand two blue curtains, as partitions in the same space, in which they are not hanging and hardly even standing, but simply existing, with a function all their own. In this orchestration they are rather like the opening bars, a modest overture, leading to the main theme in the center.

This is the setting created by a painter who takes his place in the centuries-old tradition of the theater and its curtains. In *The Memoirs of a Saint* (1960, Collection Dominique and John de Menil, Houston) the idea of a setting is used almost literally, and in 1962 it is supplied with a full musical score. At the same time, Magritte gives his apparently simple canvas the complex function of opening up a prospect onto a natural interior world, sublime and with endless perspectives, by means of an *artificial* world. The curtains are essential for this purpose, for they link the outside world with the inside world in subtle gradations which are indispensable. Magritte establishes both the scene and the audience. In his book on Magritte, Louis Scutenaire writes, "He has nothing of the actor about him. There may be many theater curtains in his canvases, but there are none to be seen in his life."[51]

According to Harry Torczyner, the extremely cryptic title is bound up with the expression of a pessimistic mood and the memory of an old street in Brussels originally named "La peine perdue" for realistic reasons, but altered, owing to a misunderstanding, into "Le pain perdu."

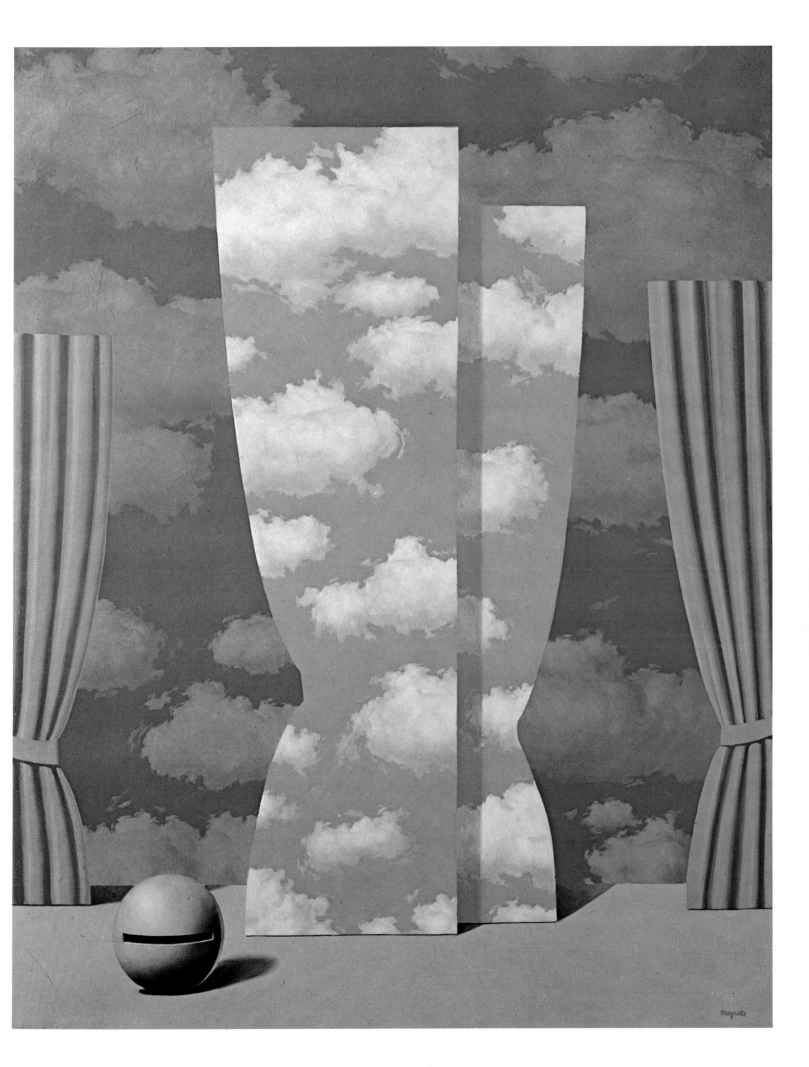

Painted 1965

SIGNATURE IN BLANK
(LE BLANC-SEING)

Oil on canvas, 31⅞ x 25½″

Collection Paul Mellon, Washington, D.C.

Were it not for the horse and the elegant, expressionless horsewoman, this canvas might seem like a normal summer woodland scene. But this too is an illusion, for between the dark leaves of the tree trunks in the foreground and the small trees (perhaps fruit trees?) at the edge of the woods at the back we notice, on closer scrutiny, a curtain or backdrop behind the trees—foliage, kept in pale tones, of which it is difficult to say to what, or to which trunks, it actually belongs. Yet it is lively and attractive in its effect, taking the place of the sky and depriving the picture of depth.

This last point recalls a rarely noted explanation made by Magritte, and quoted by Scutenaire, regarding the abstract nature of painted images in contrast to the concrete nature of real life: "Despite the complicated combination of details and nuances in a real-life landscape, I succeeded in seeing it as though it were a backdrop let down before my eyes. I became unsure of the depth of the landscapes, little convinced regarding the distance of the pale blue of the horizon, direct experience situating it simply at eye level. I was in the same state of innocence as the child who thinks it can grasp the bird flying in the air from its cradle."[52]

This was the discovery of a very different kind of abstraction from that to which Cubism had led. At the same time it marked a departure from the concept of space subject to the projection of perspective. This evolution in Magritte's work of pre-Renaissance space, in which movement is frustrated and the depth uncertain, opens up to him the possibility of inventive play with imaginary spaces.

Magritte had the extremely subtle and deceptive idea (deceptive because of his very precision) of having the horsewoman and her mount move in two planes. Between two trunks the normal backdrop of foliage is visible, and this conceals a portion of the horse and reins, the horse appearing to be passing between the same two trunks. Spatially, the rider and the woods become an absurdity, due to this section of the intruding background, the position of one of the horse's hind legs, and another tree trunk in the background, part of which passes in front of the horse and rider. A small click in the conception of space, and the absurd appears on the scene. Thus, in his mind, Magritte developed the possibility of a different kind of universe.

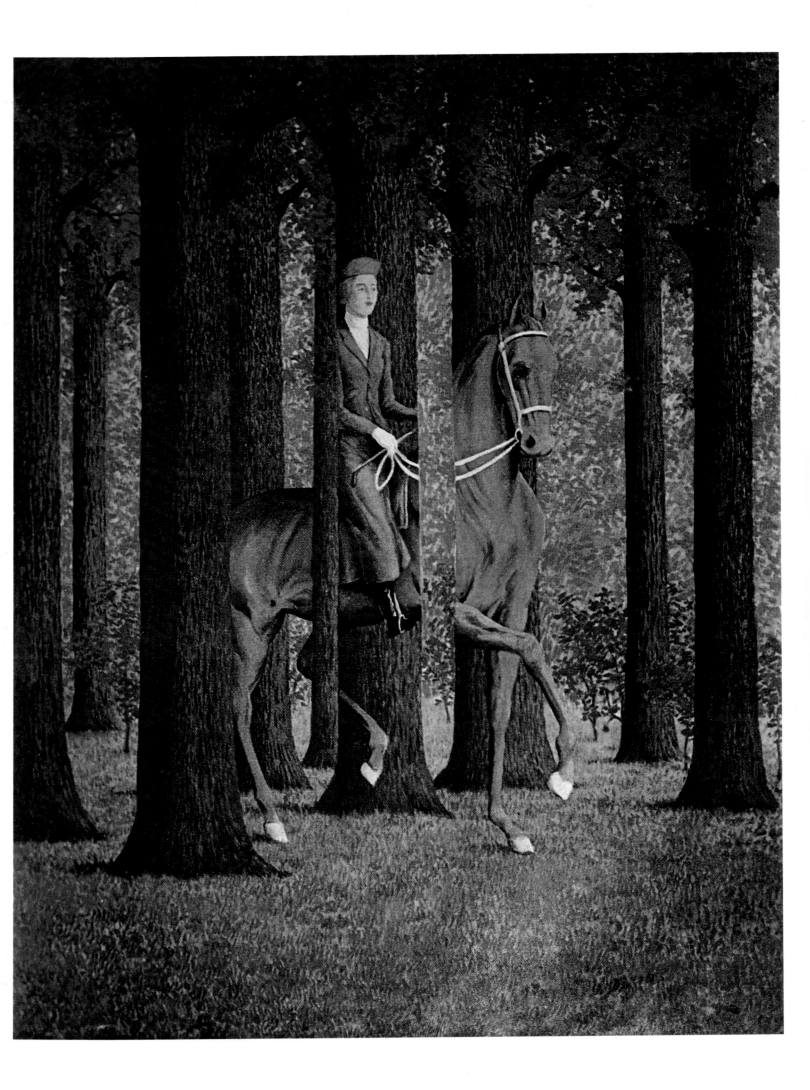

Painted 1967

THE ART OF LIVING
(L'ART DE VIVRE)

Oil on canvas, 25½ x 21¼"

Collection Alexandre Iolas, Paris

In the year he died, Magritte painted *The Art of Living* for Alexandre Iolas. It is composed of familiar features from his oeuvre: full-face portraits of "ready-made" citizens, decapitated and ranged in front of a stone balustrade against a background of mountains. As so often in Magritte's works, there is also something new. Here an enormous balloon is floating above the decapitated body, and the balloon is the head. It is pink, a color Magritte was already using before 1930 and remained fond of for certain situations. Inside the balloon is a very small complex of eyes-nose-mouth which seems mysterious yet is not, for it is the expression of normalized vacuity, like the ready-made suit, which nevertheless represents a human being and hides everything that must remain secret—the small sins which convention prescribes, the major sins which society forbids. It is the image of the unremarkable which strikes us by being so *very* unremarkable.

Undeniably present in this representation of the bourgeois citizen is an element of that "objective humor" which André Breton opposed to "subjective humor" in his lecture "The Surrealist Position of the Object."[53] Breton found this objective humor to be triumphantly present in the work of Alfred Jarry, the playwright, and also in the work of the Futurists and Dadaists. Magritte's devastating criticism of the average citizen manifests itself once more in this late work, in the objective humor of the enormous balloon in a striking pink, the color representing the charm of the good life, which is here the skin that covers self-satisfaction and vacuity.